PORTABLE
COLOR ME
CALM

Quarto is the authority on a wide range of topics.

Quarto educates, entertains and enriches the lives of our readers—enthusiasts and lovers of hands-on living.

www.quartoknows.com

© 2015 Quarto Publishing Group USA Inc.

First published in the United States of America in 2015 by Race Point Publishing, a member of Quarto Publishing Group USA Inc.
142 West 36th Street
4th Floor
New York, New York 10018
Telephone: (212) 779-4972
Fax: (212) 779-6058
quartoknows.com
Visit our blogs at quartoknows.com

10 9 8 7 6 5 4 3 2

ISBN: 978-1-63106-186-8

Library of Congress Cataloging-in-Publication Data is available

Printed in China

This book provides general information on various widely known and widely accepted images that tend to evoke feelings of calm in individuals. However, it should not be relied upon as recommending or promoting any specific diagnosis or method of treatment for a particular condition, and it is not intended as a substitute for medical advice or for direct diagnosis and treatment of a medical condition by a qualified physician. Readers who have questions about a particular condition, possible treatments for that condition, or possible reactions from the condition or its treatment, should consult a physician or other qualified healthcare professional.

PORTABLE
COLOR ME
CALM

70 Coloring Templates for
Meditation and Relaxation

Lacy Mucklow, MA, ATR-BC, LPAT, LCPAT
Illustrated by Angela Porter

Race Point
PUBLISHING

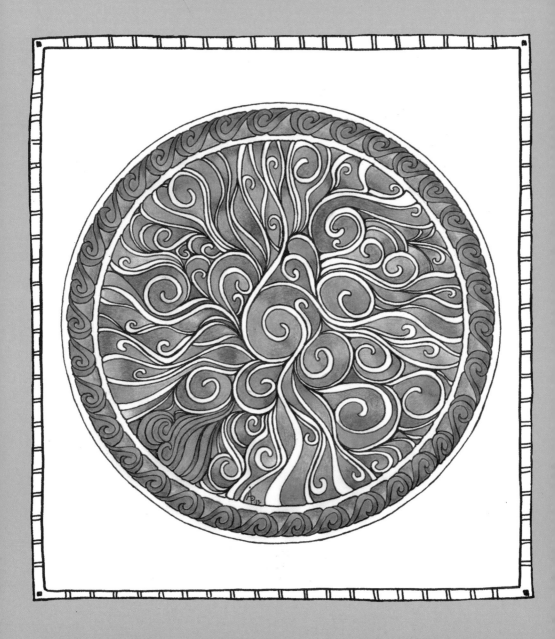

CONTENTS

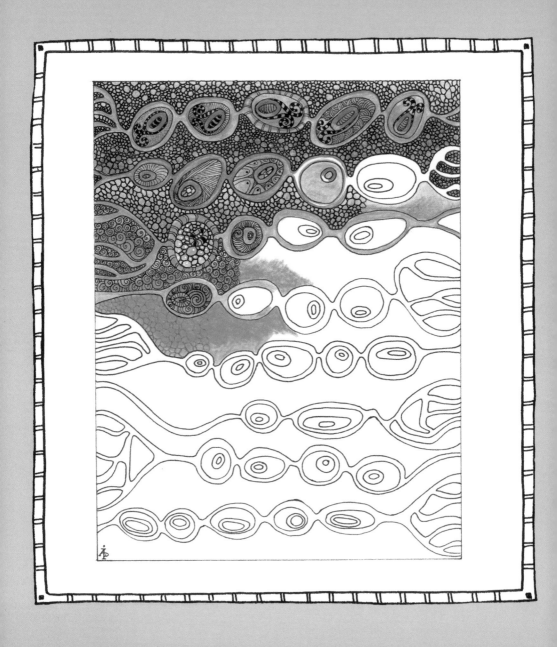

INTRODUCTION

Why make a coloring book for adults? As children, many of us enjoyed coloring in our favorite characters or scenes in books with our trusty pack of crayons. But as we got older, added responsibilities came along that pushed aside all those things we used to do for sheer enjoyment.

One of the great things about coloring is that it is highly accessible for everyone, even if you lack artistic instruction or experience, and it can be as nuanced or generalized as the colorer wishes. Having guidelines eases performance anxiety for many, and being able to add our own colors helps make the experience more personal. The act of coloring can also be meditative in and of itself, bringing about calmness just through the simple act of picking up a colored pencil or crayon and focusing your creativity and thoughts on a single coloring exercise.

Despite what you may have learned about art and color in your lifetime, there is no right or wrong way to color and there is no right or wrong way to use this book; you have the freedom to color it in however you wish and in whatever way works best for you. Conceptually, in "Color Me Calm," the images chosen fall into topics that are universally

found to evoke more relaxing responses in people, such as mandalas (often used for concentration, meditation, and calming), different aspects and patterns from nature (often inspirationally calming for people), geometric patterns (regular, symmetrical patterns can also be meditative), as well as water themes (envisioning steady or rhythmic flows and picturesque scenery can be soothing). The act of meditative coloring combined with the carefully chosen subject matter in this book are meant to work together to create a powerful calming experience for the reader.

We realize that what relaxes people can run the gamut even within "universal" categories, so we have tried to include a variety of choices within each chapter so that at least some pieces may connect with you personally. The designs are intended for adult sensibility and dexterity rather than children, and include actual scenes (or variations thereof) of typically calming subjects, and many are more abstract in nature so that you may enjoy the intricacy of the patterns themselves, as so many of us do. This is about getting in touch with what makes you feel calm, so if one coloring template does not appeal to you, simply move on to one that does.

At the end of each chapter we have also included a blank frame so that you may have a chance to think about and draw an image that is uniquely calming to you. This will make the coloring experience even more personal and will hopefully keep you mindful about things and experiences which you find calming. You may find that using

this book in a regular routine may be particularly helpful for you, such as beginning your morning with a coloring template to help you set a calm and mindful tone for the day or coloring before going to sleep to help your body and mind wind down. This book is intended to help bring you to a relaxed emotional state as a way to help you self-soothe; however, it is not meant to replace the services of a professional therapist if more direct intervention and personal guidance are needed. We hope that you enjoy this book and that it helps you find a way to color yourself calm!

—Lacy Mucklow, MA, ATR-BC, LPAT, and LCPAT

COLOR TIP

Cool colors (such as blues, greens, and purples) are considered to have calming qualities, while the warmer colors (such as red, oranges, and yellows) have more activating qualities. Bright colors tend to have more energy while pastel or tinted colors tend to communicate softer energy and darker colors or shades usually indicate lower energy. The most important thing is to figure out which colors *you* find soothing, and then try to incorporate them into your artwork.

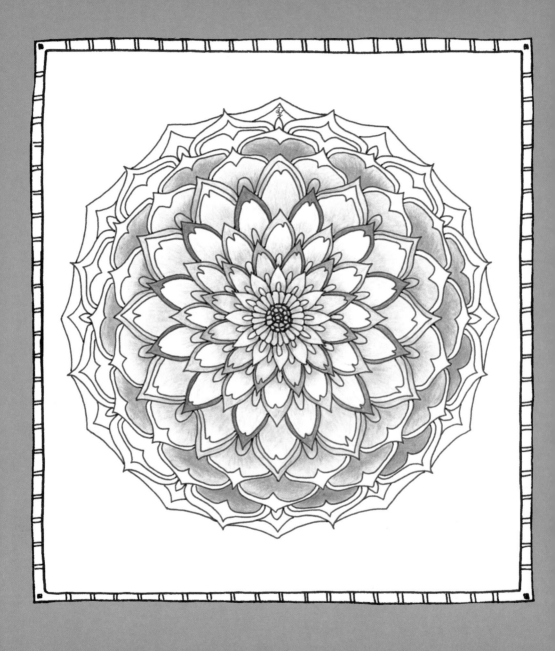

Chapter 1

MANDALAS

The word "mandala" comes from a Sanskrit word meaning "circle" or "round," and has even been translated as a "container of the sacred space." Essentially, a mandala is anything represented within a circle. The circle shape itself is considered to be whole and uniform, and is generally perceived to be a more calming shape to draw within than more straight-edged forms. The circular, or spherical, shape is often found in nature and has been used throughout time and history as a meditative shape, especially within Eastern and Native American cultures. Even today, Buddhist monks create their intricate mandala sand paintings in public forums for others to observe. The use of the mandala in art became especially popular after the psychologist Carl Jung incorporated it into his professional and personal lives. While some find open mandalas and the freedom of drawing whatever they desire to be contemplative, the coloring in of predesigned mandalas has been shown to help reduce anxiety, especially those mandalas with symmetrical, repetitive, and/or geometric patterns. In this chapter, a selection of predesigned mandalas has been included for you to color, with an open template at the end to design a mandala as you wish.

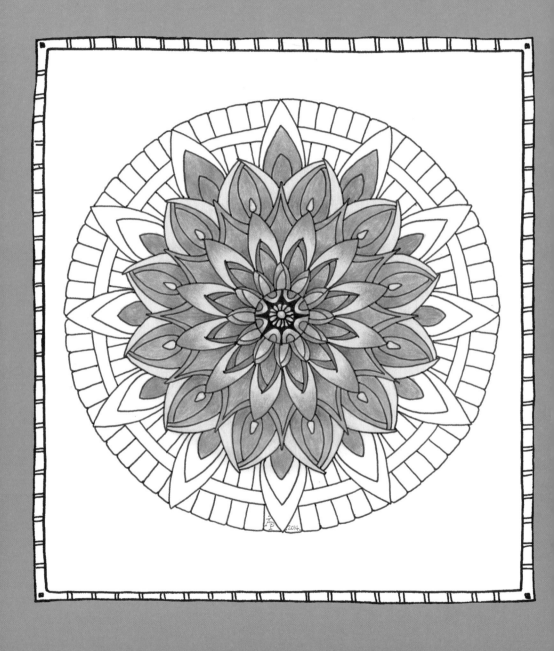

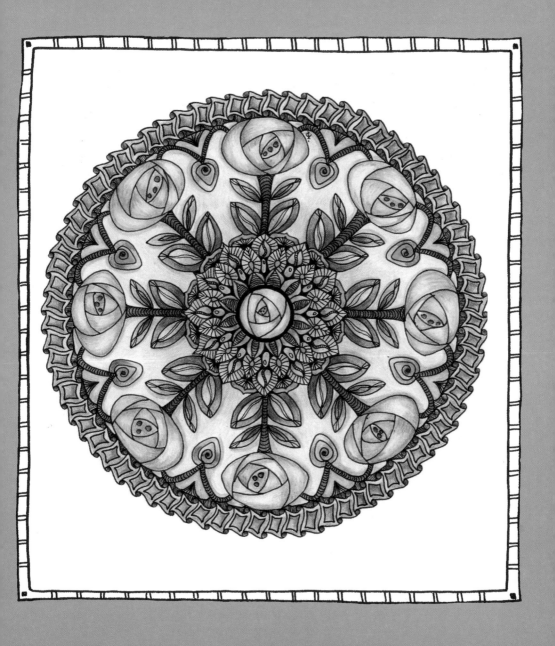

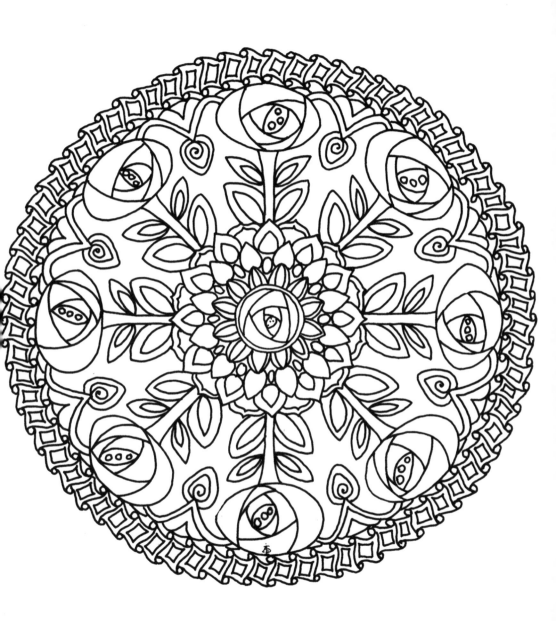

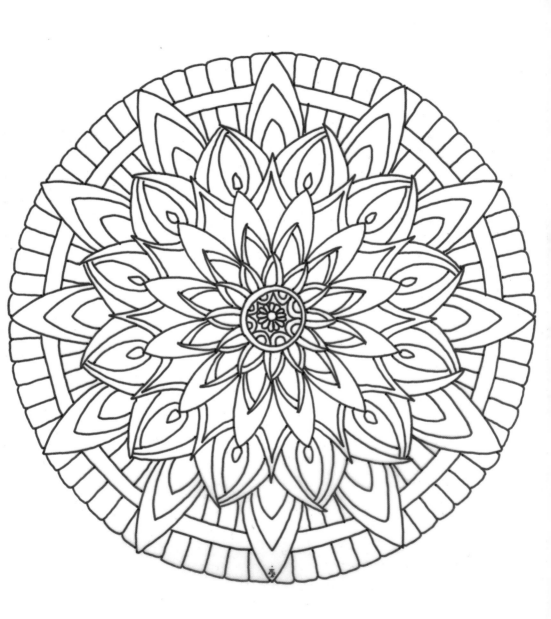

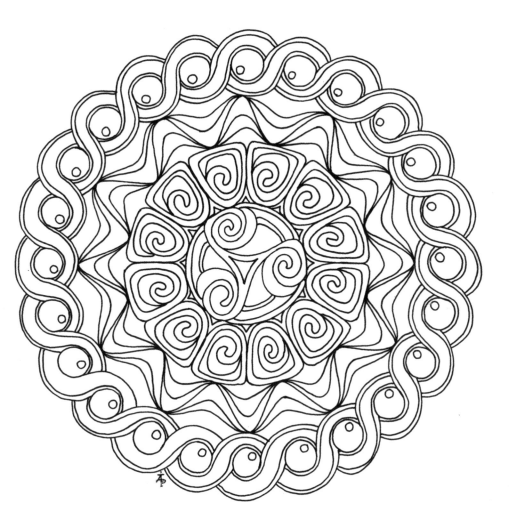

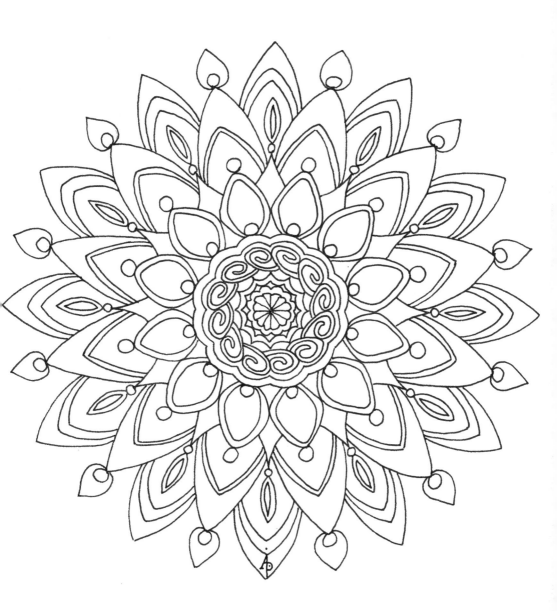

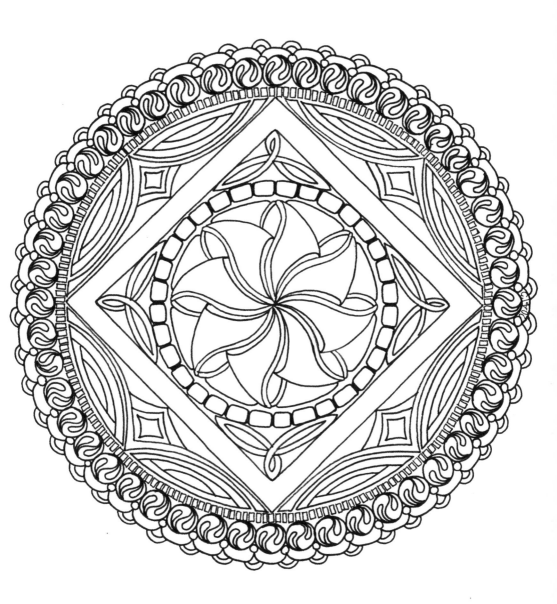

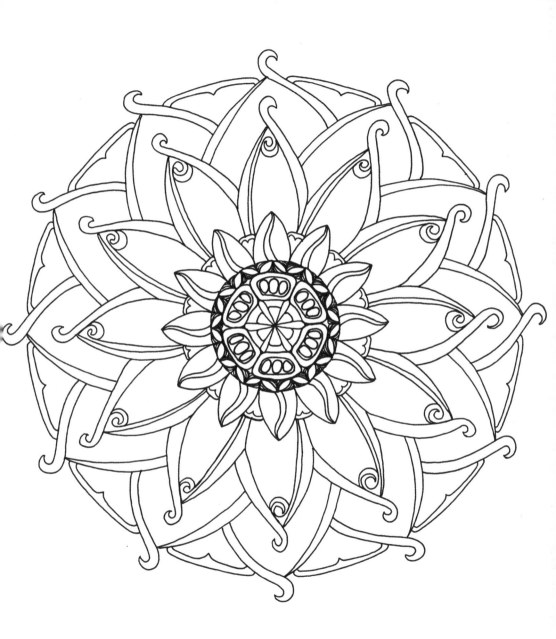

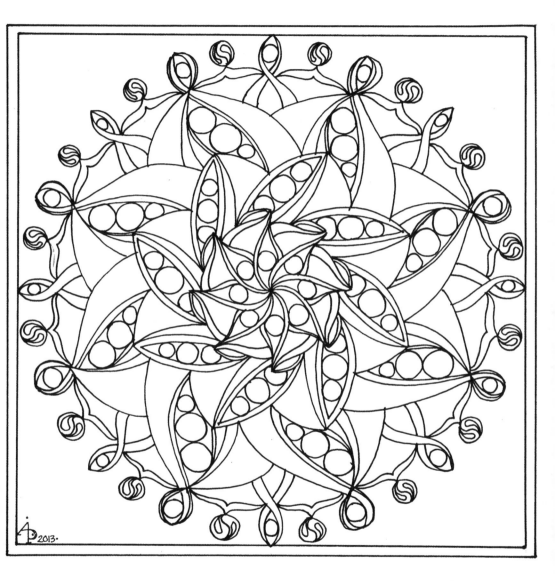

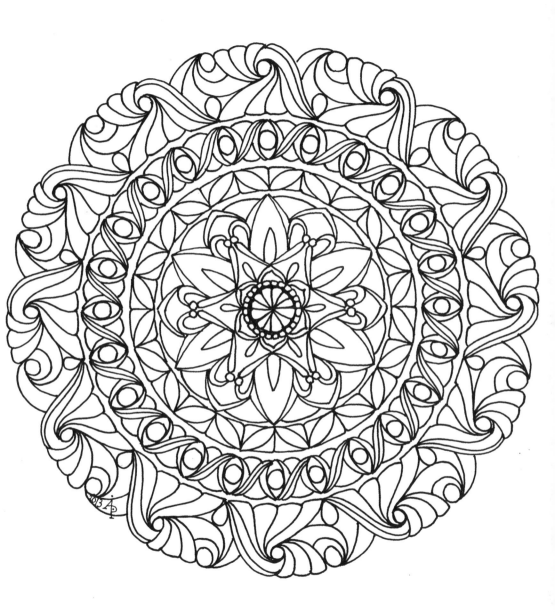

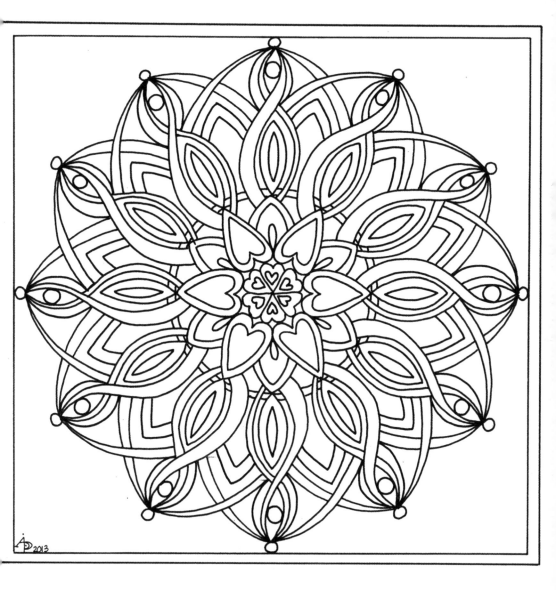

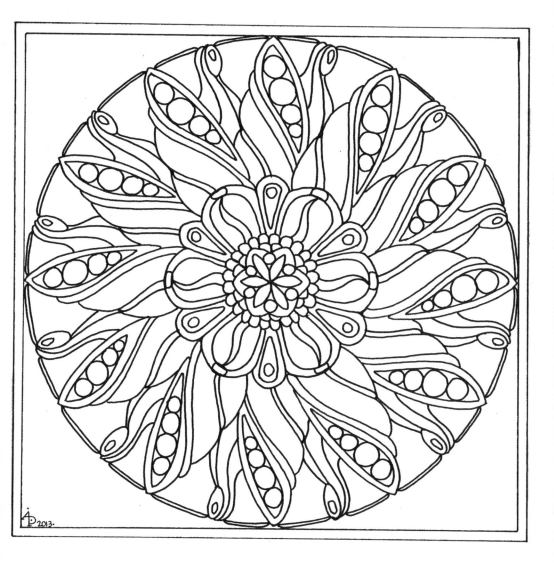

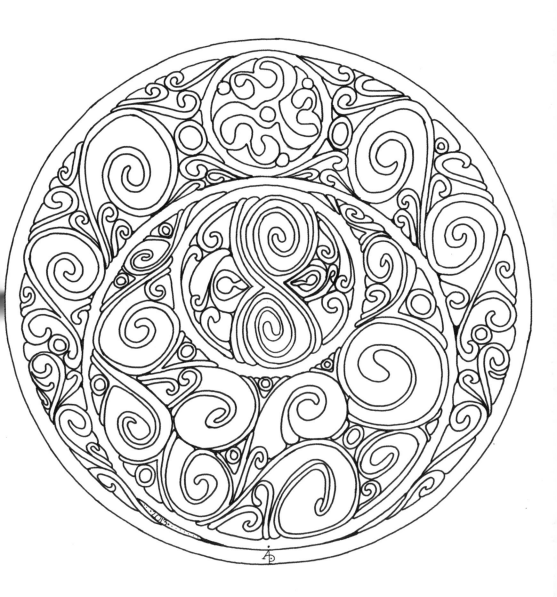

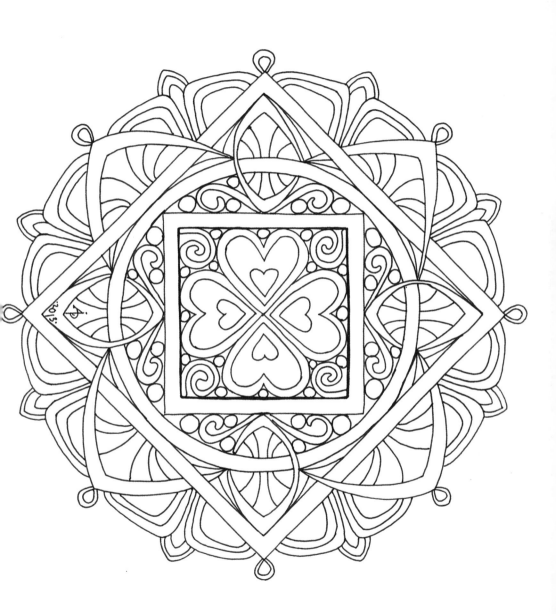

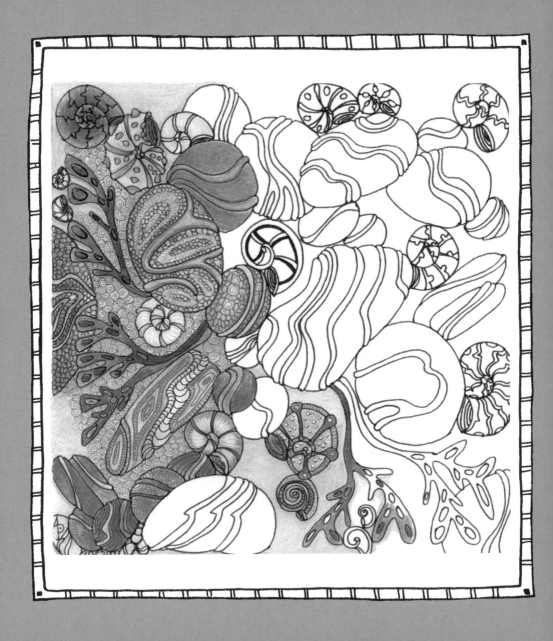

Chapter 2

WATER SCENES

Water scenes are relaxing for many people, especially photographs and artwork of beaches and oceans. Music with ocean waves in the background also has a calming effect, as the ebb and flow of waves represents the heartbeat of nature, and may even be associated, subconsciously, to hearing one's mother's heartbeat while in the womb. Aside from ocean scenes, many people also find serenity in environments of still water, such as lakes or ponds, or moving water, such as streams, creeks, fountains, waterfalls, or rivers, especially as a soothing white noise. Additionally, water scenes are often associated with vacation, relaxation, and fun, a reminder of a more stress-free time. Most importantly, water is a basic need of life and makes up approximately 70 percent of the human body. As you consider coloring the following pictures you may relate them to scenes you have actually visited or can envision in your mind to determine your color choices. There is also a blank panel at the end of this chapter where you might feel inclined to draw a relaxing water scene that is special to you.

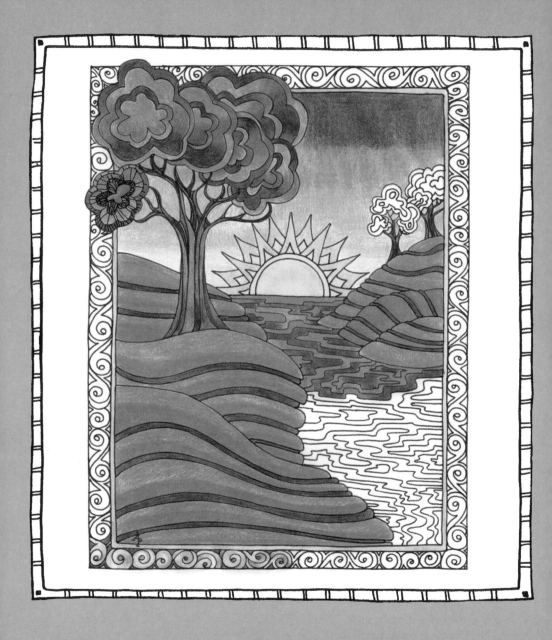

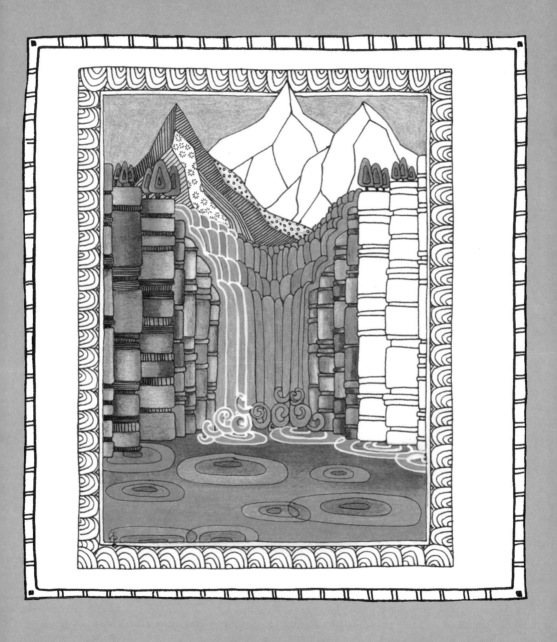

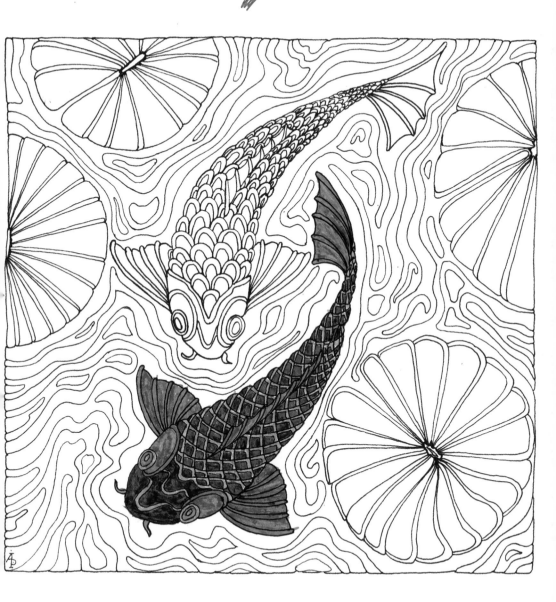

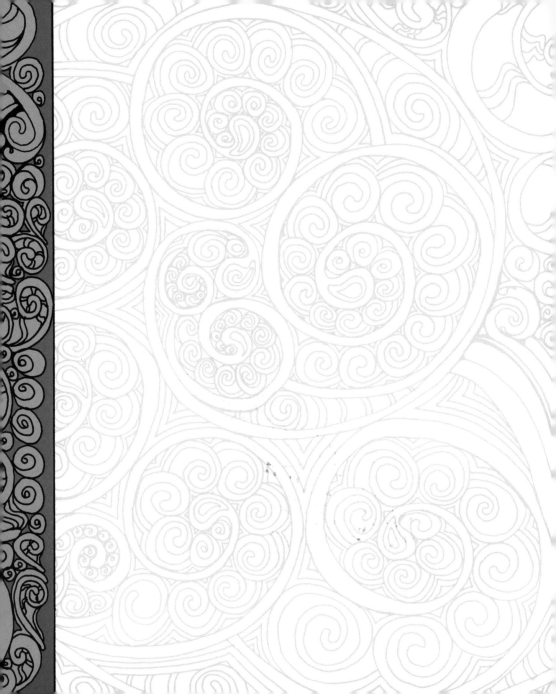

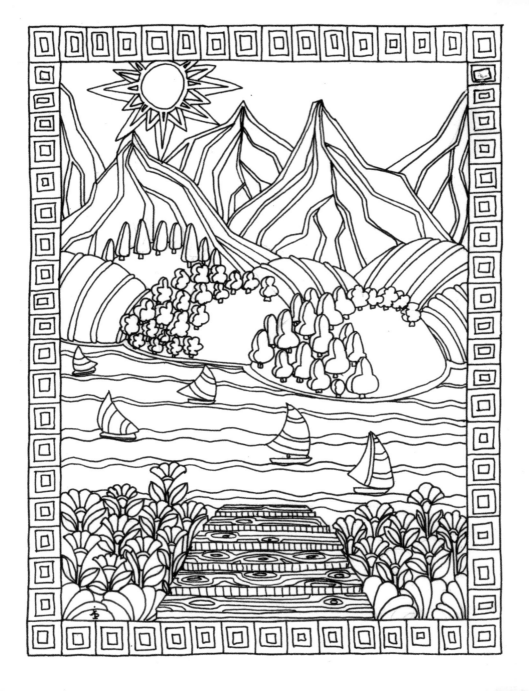

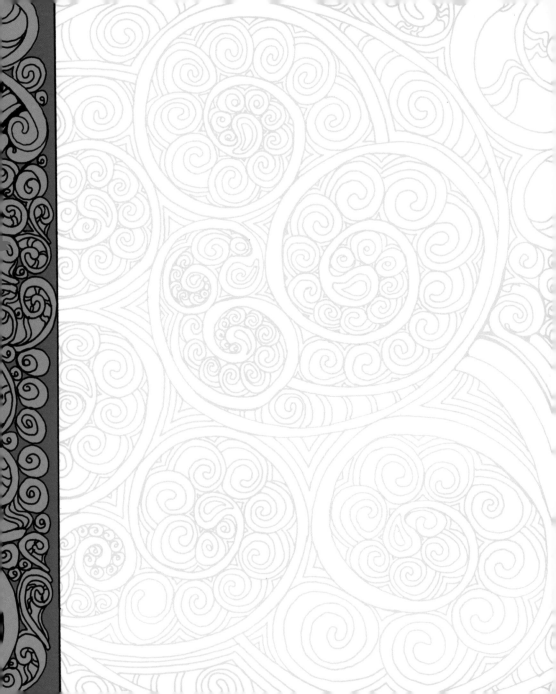

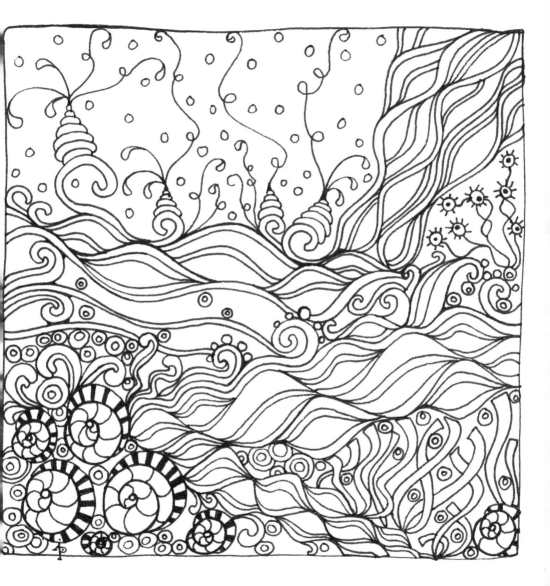

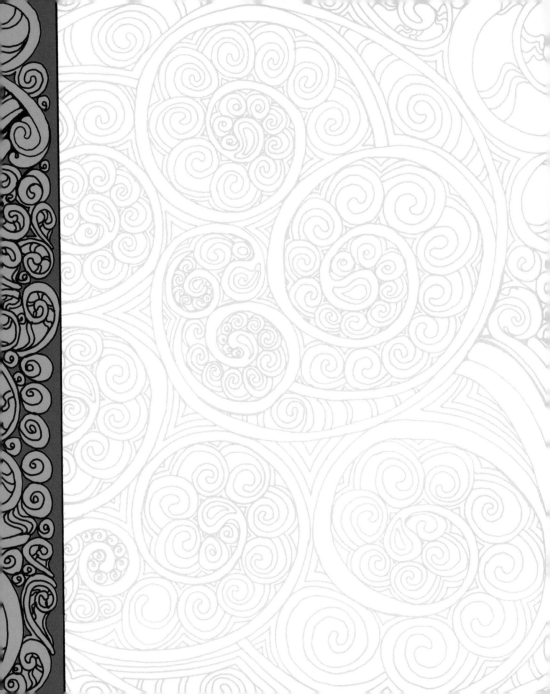

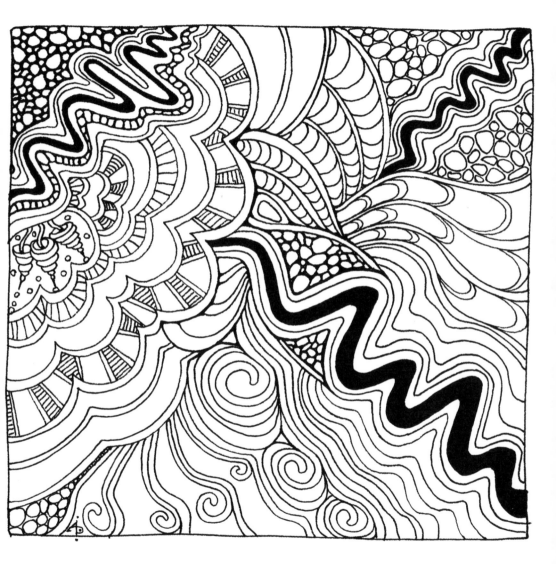

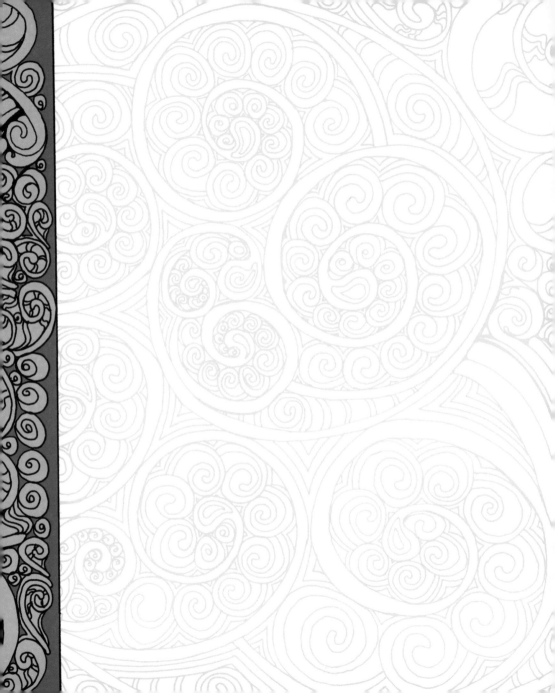

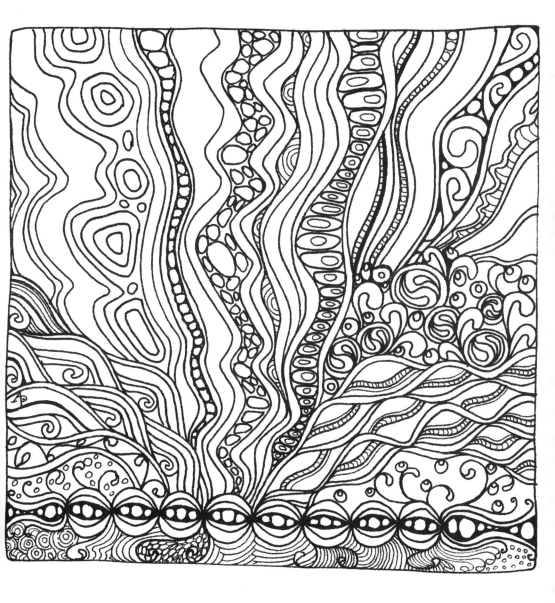

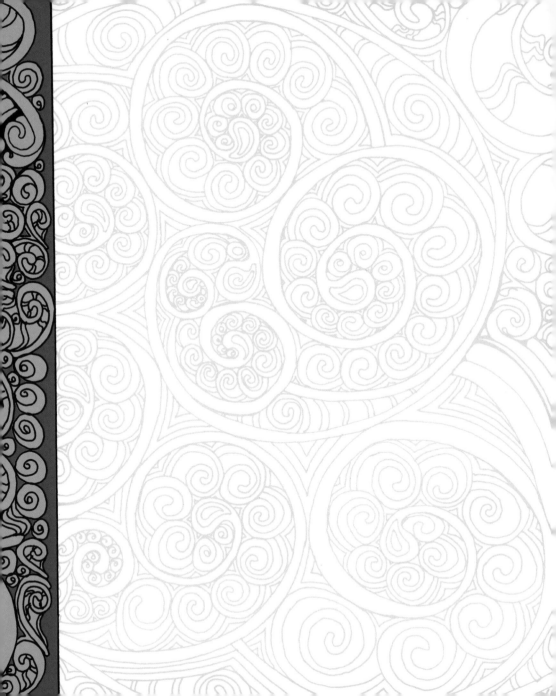

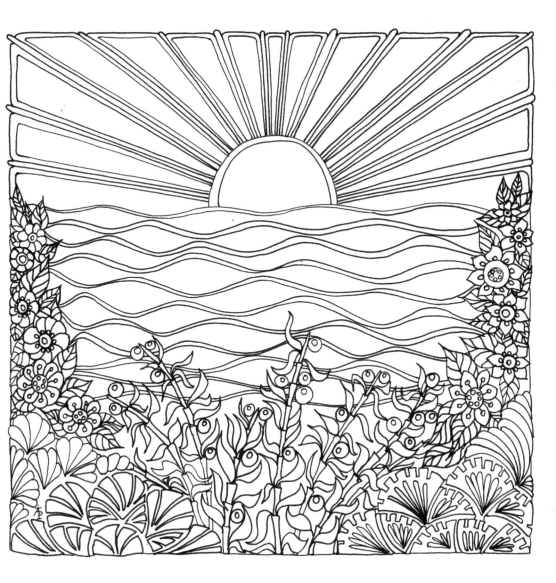

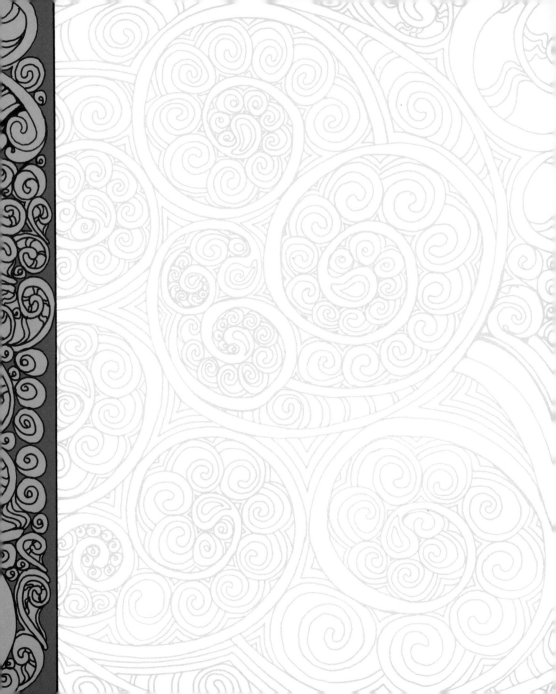

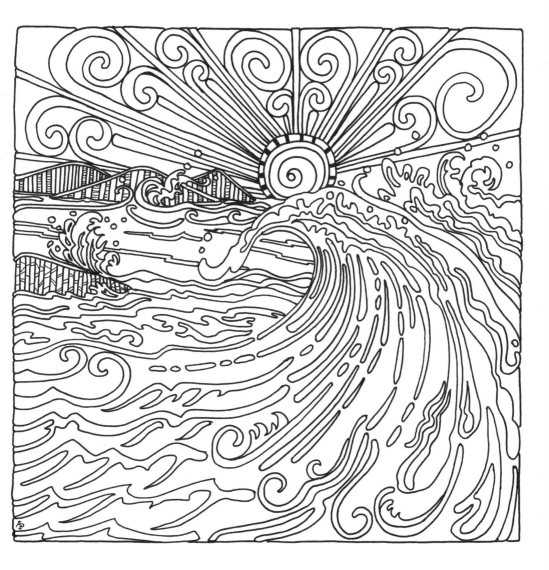

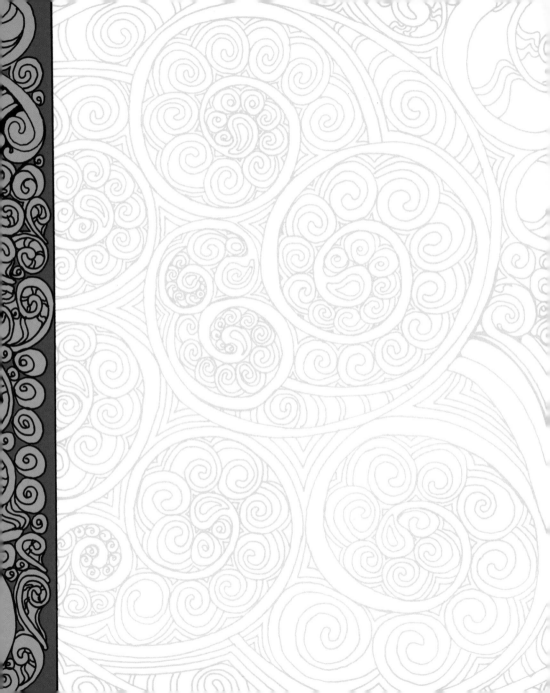

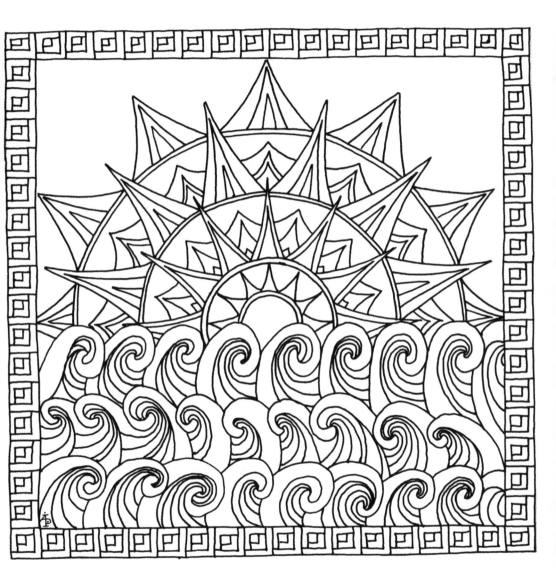

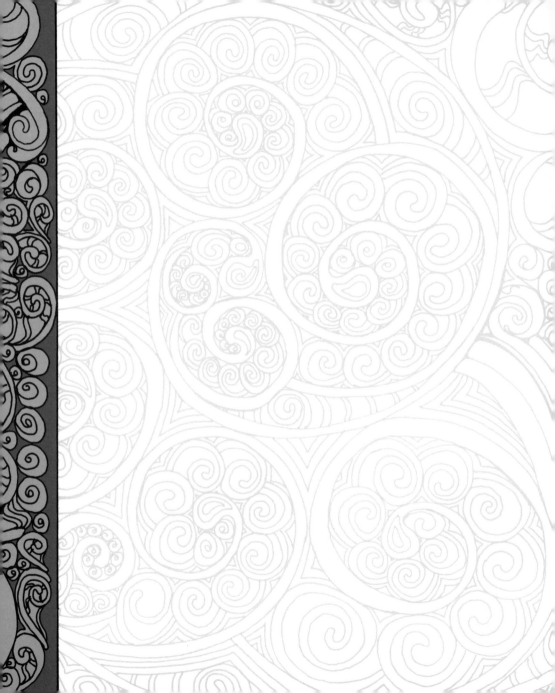

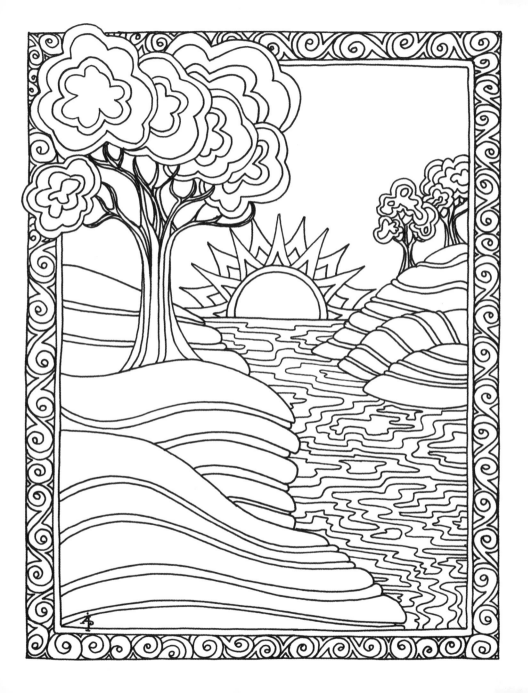

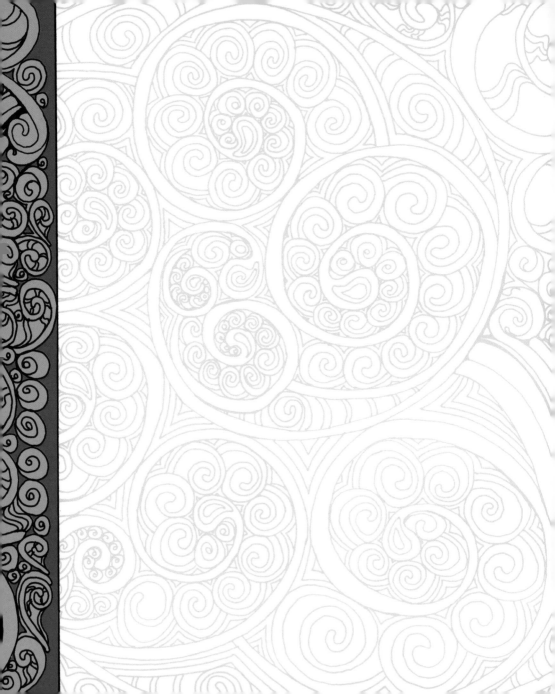

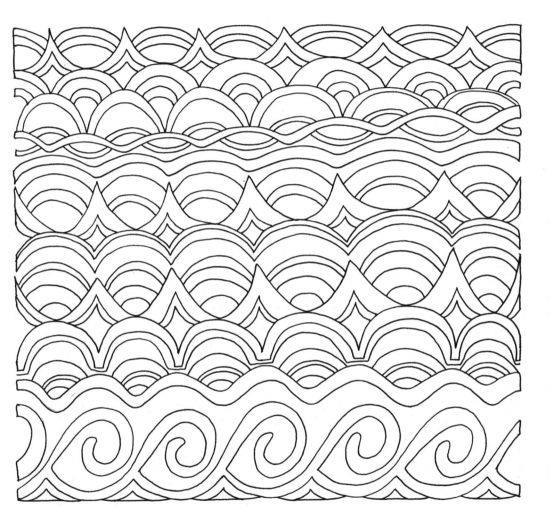

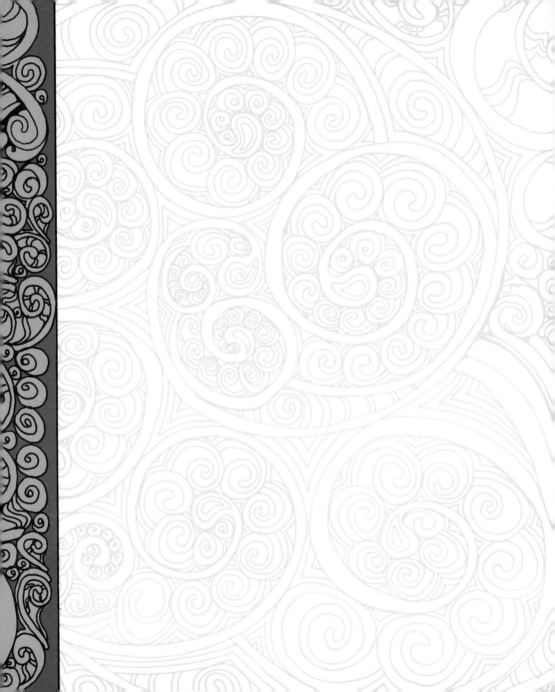

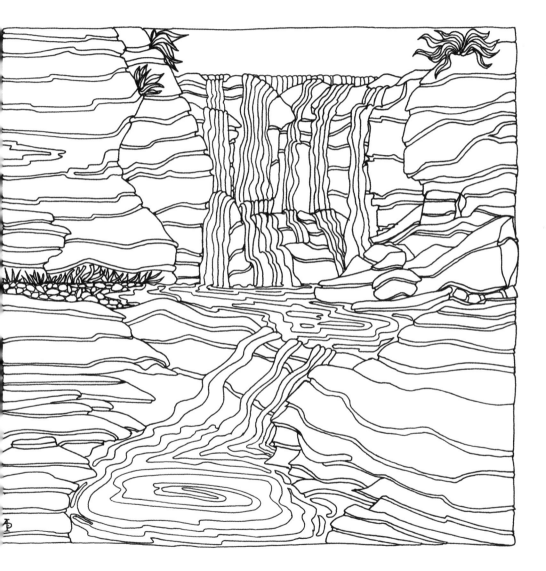

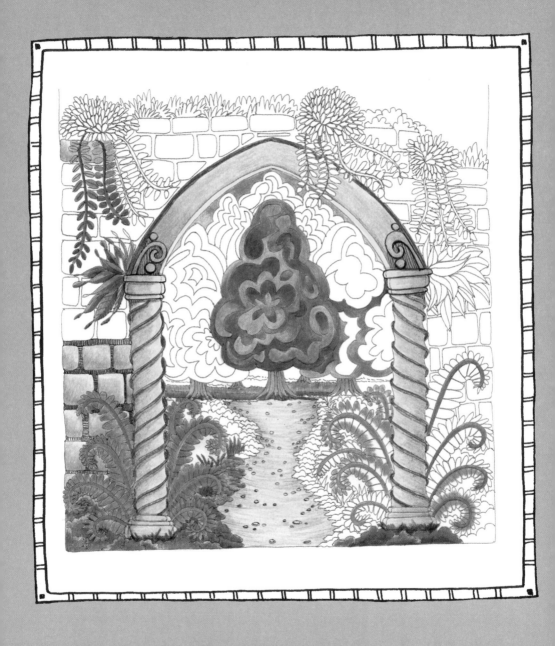

Chapter 3

WOODED SCENES

Quiet scenes of wooded areas can evoke calming feelings as one gets back to nature, away from the busy pace of a more urban area. Locales in forests or mountains can seem especially cozy when depictions of cottages or cabins, campfires and wood-burning stoves, or hot cocoa and tea are included in the scene. When people have been asked to think about and draw their "safe place," wooded areas are frequently included as part of their scenario where they can envision being calm or grounding themselves from situations of anxiety or trauma. Mountain or forest scenes are also used for visualization exercises for relaxation, calming, or grounding. Sometimes just thinking about rushing water, crackling fires, the smell of pine trees, or the feel of crisp mountain air can help one feel more at peace. As you consider coloring the following pictures, you may relate them to scenes you have actually visited or can envision in your mind to determine your color choices. There is also a blank panel at the end of this chapter where you might feel inclined to draw in a relaxing wooded scene that is special to you.

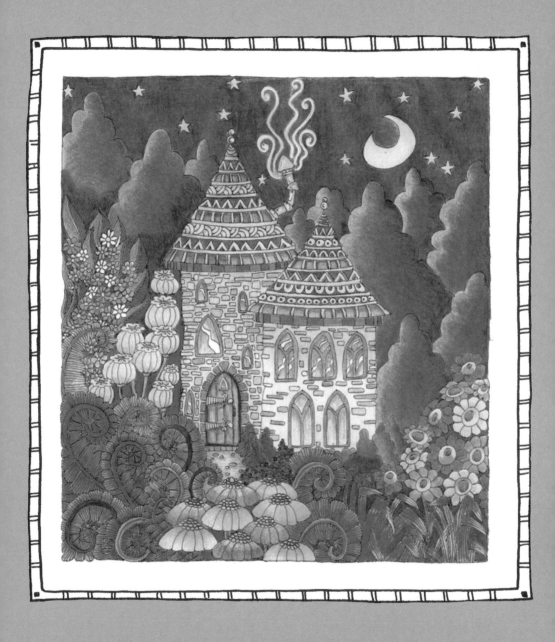

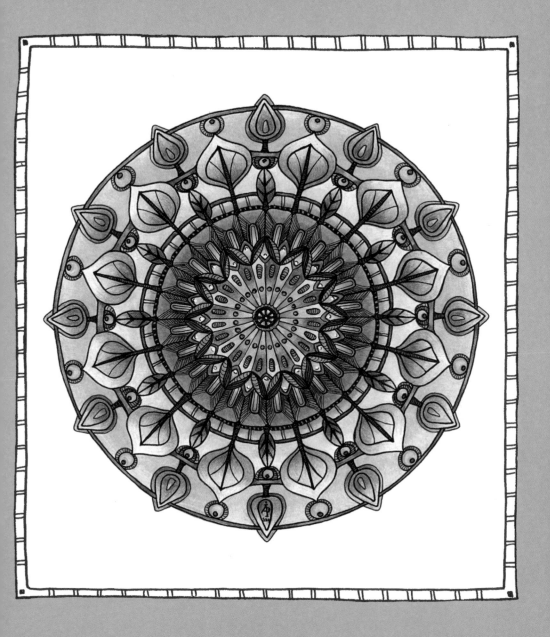

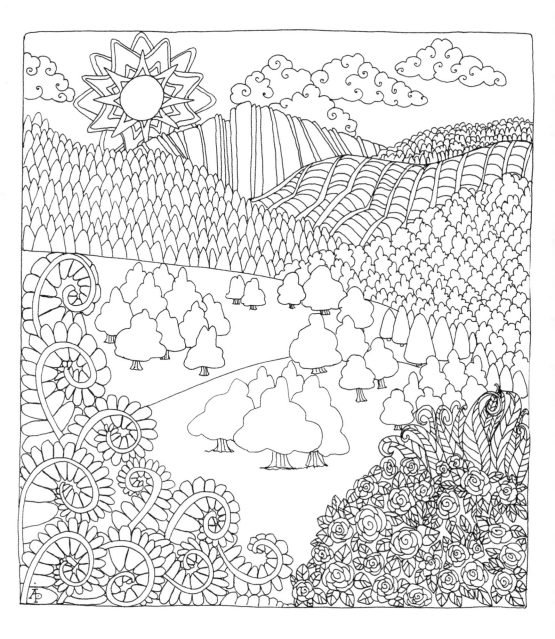

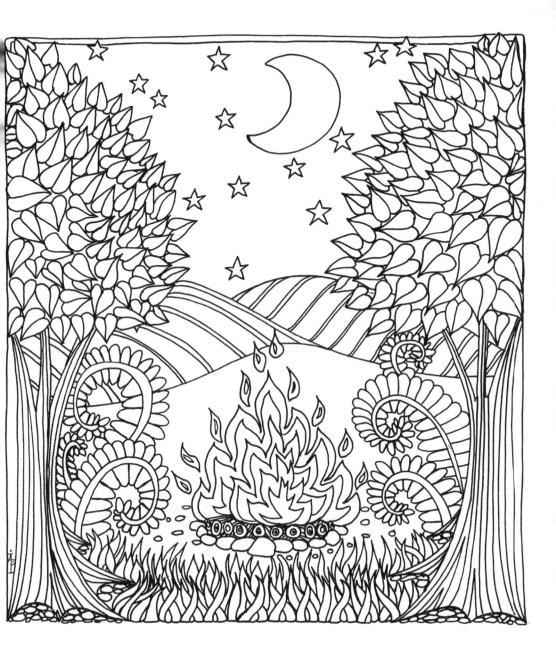

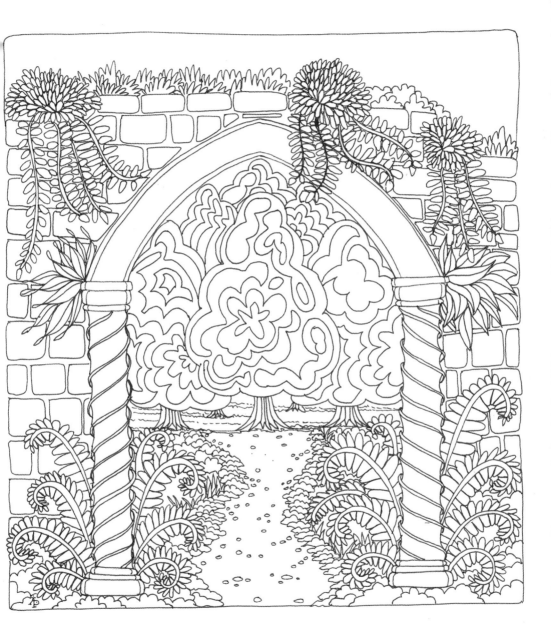

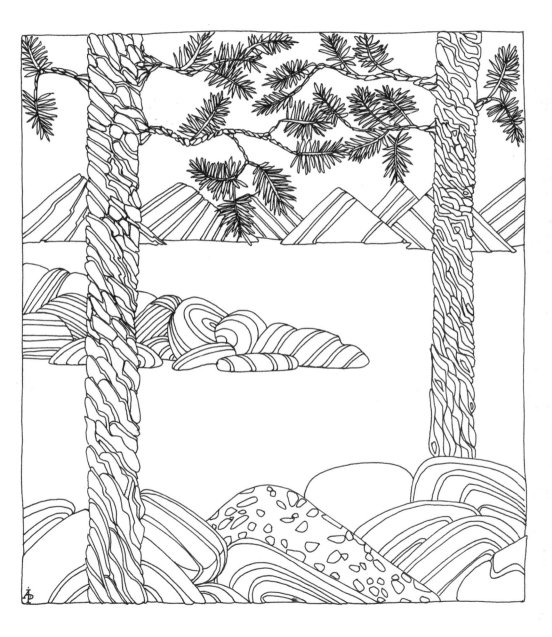

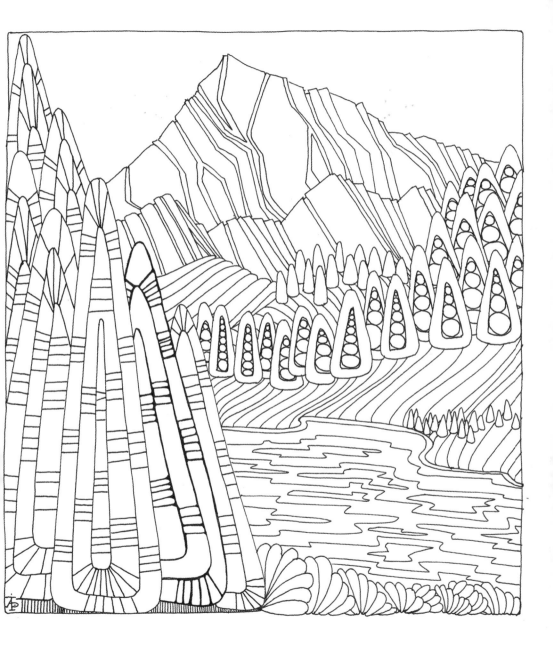

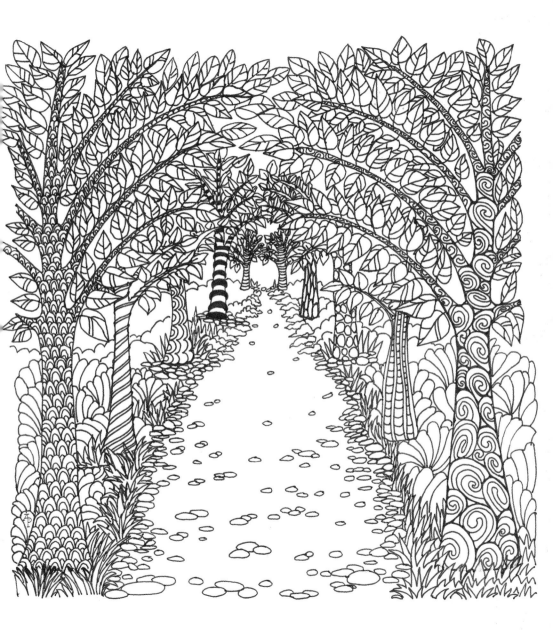

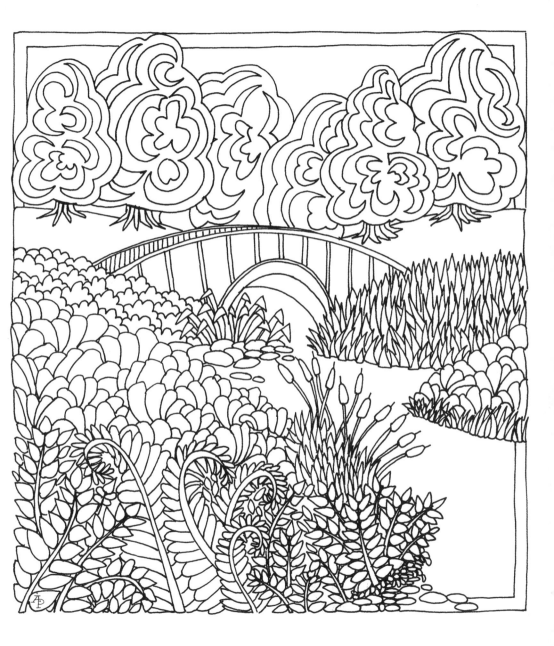

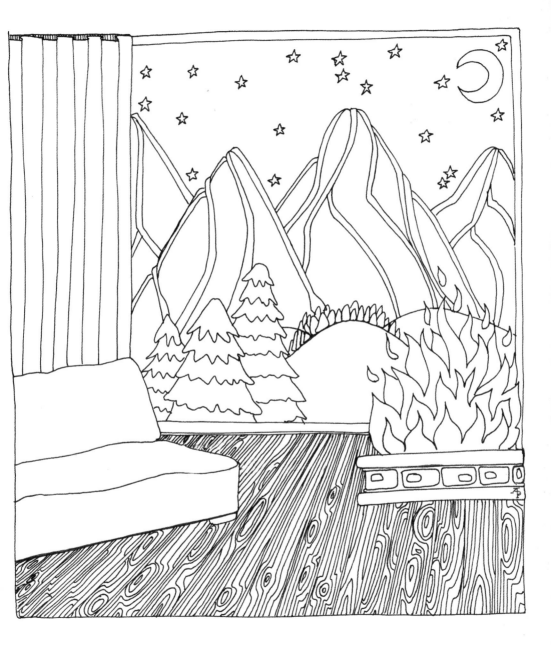

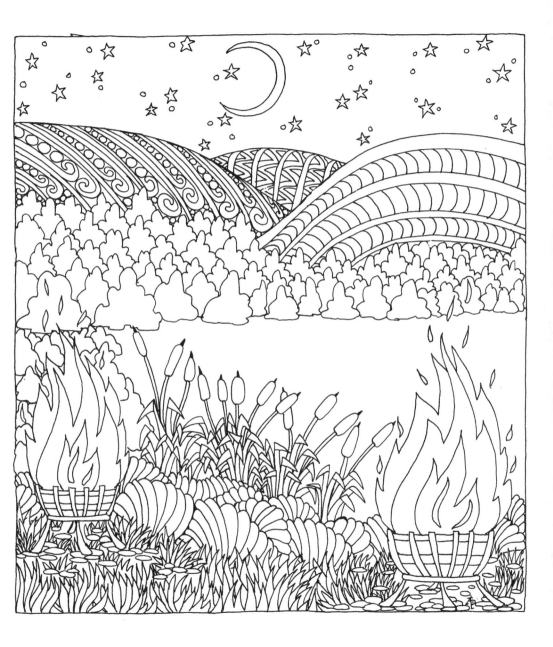

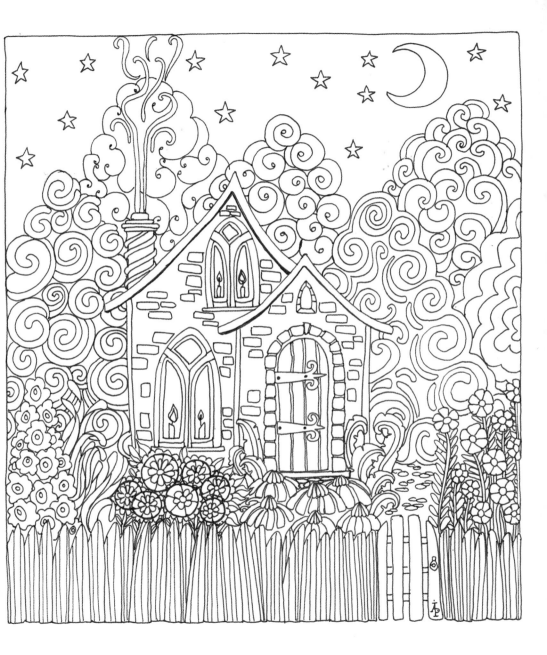

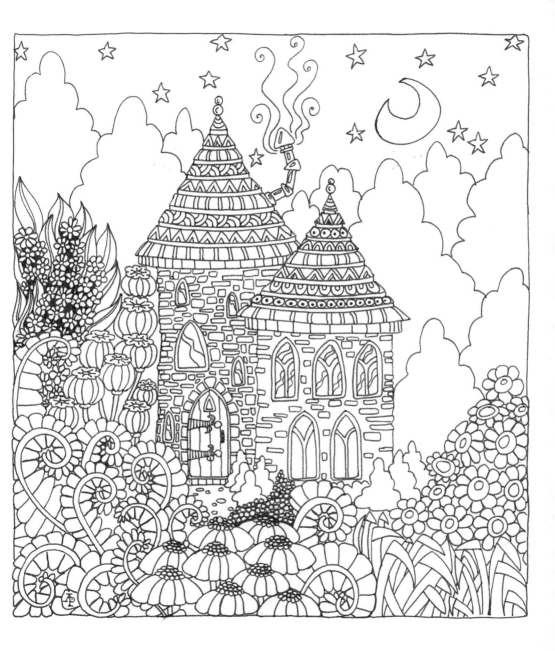

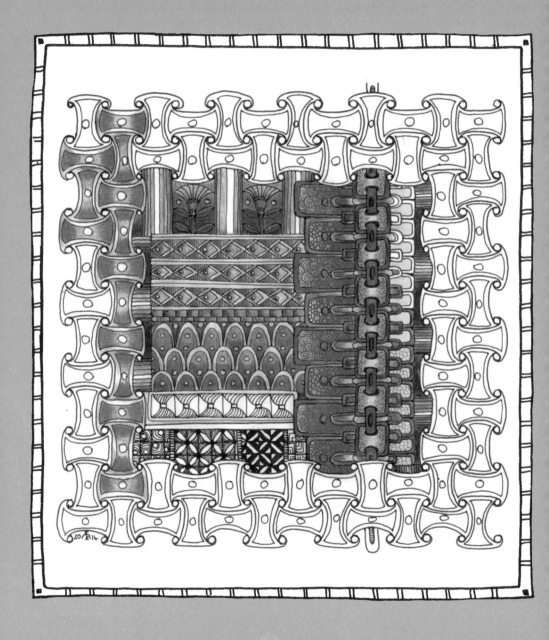

Chapter 4

GEOMETRIC PATTERNS

Geometric patterns often have a mathematical basis as well as a symmetrical design that visually communicates something that is balanced, and that sense of balance can evoke order, calmness, and focus. Even asymmetrical patterns—like the spiral of the Fibonacci series and the dimensions of the Golden Ratio—convey a sense of balance because of the exponential and logical patterns they create. The organic, geometric patterns found in nature, such as in nautilus shells, crystals, and snowflakes, can also be soothing. Repetitive designs, especially complex ones, are anything but boring to color and can even bring about a sense of concentration and meditation while coloring them. As you consider coloring the following geometric designs, you may decide on a particular color scheme, or you may want to try a complementary color scheme or a spectrum within one color. There is a blank panel at the end of this chapter to encourage you to draw and color a pattern that makes you feel balanced.

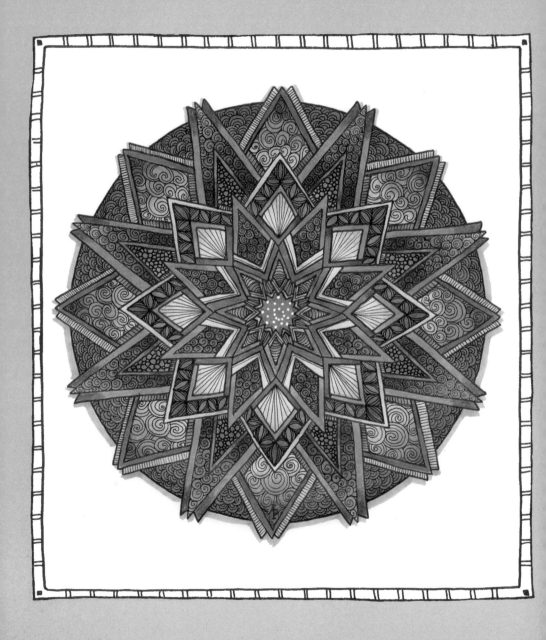

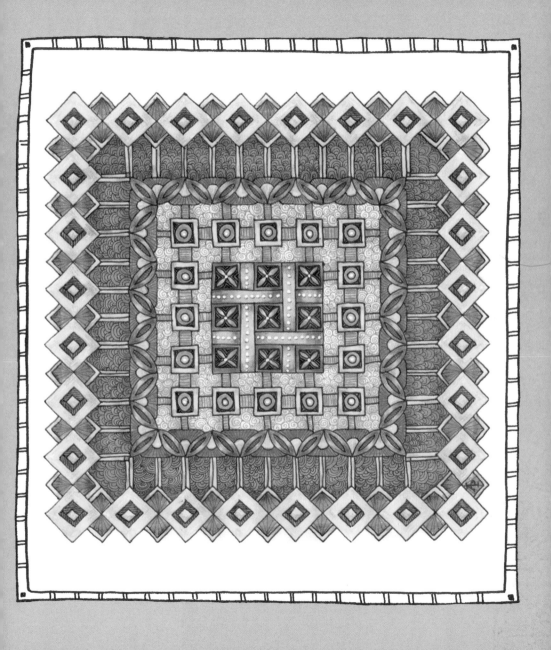

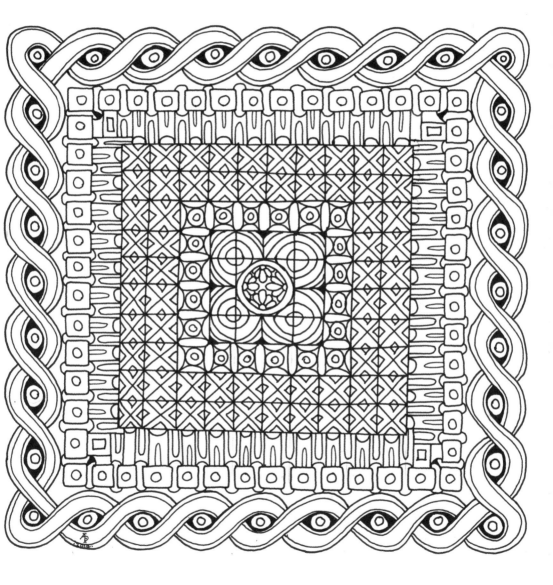

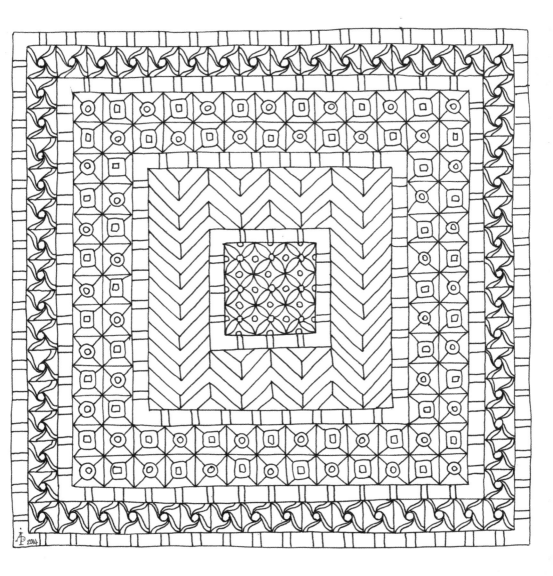

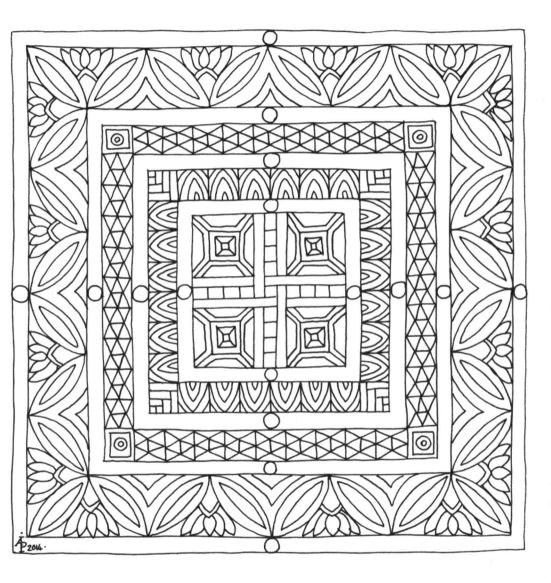

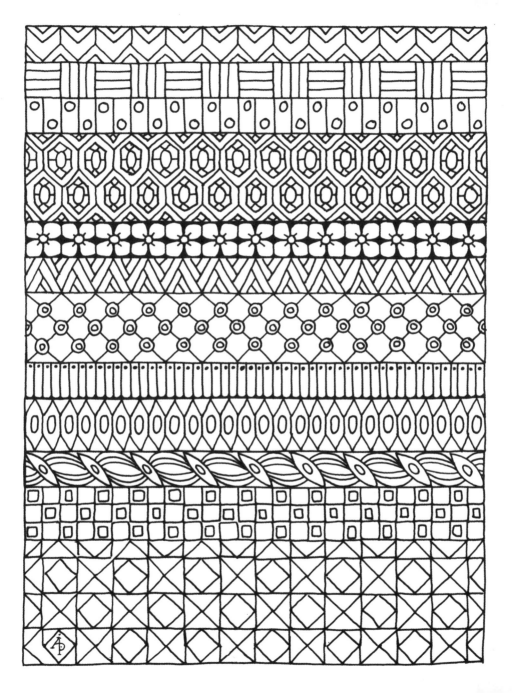

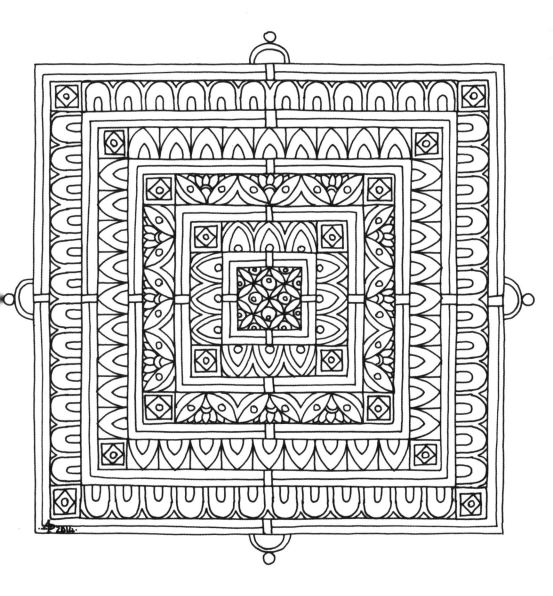

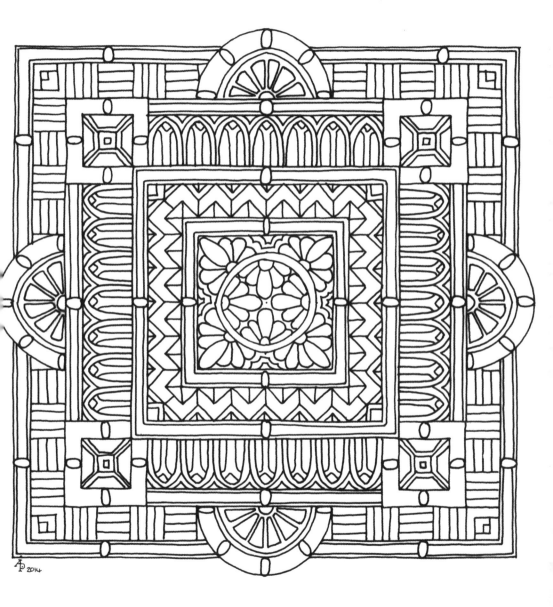

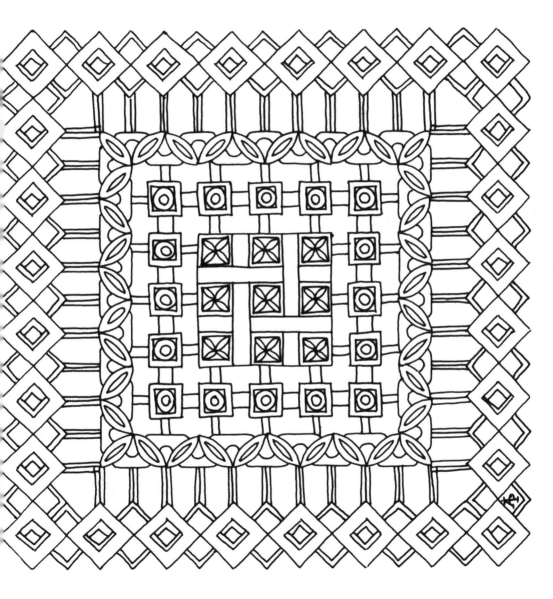

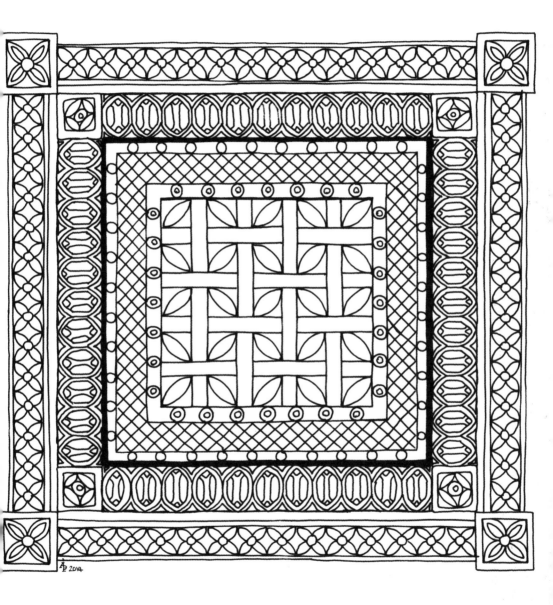

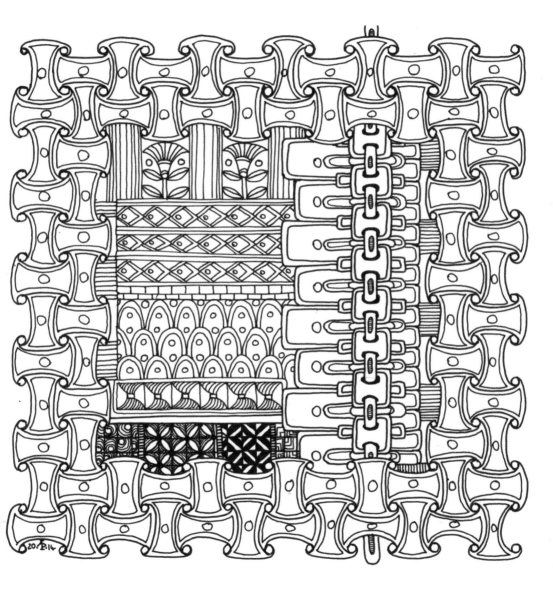

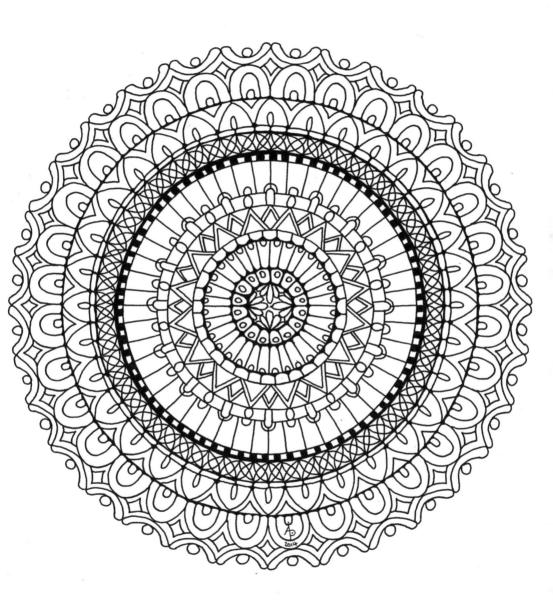

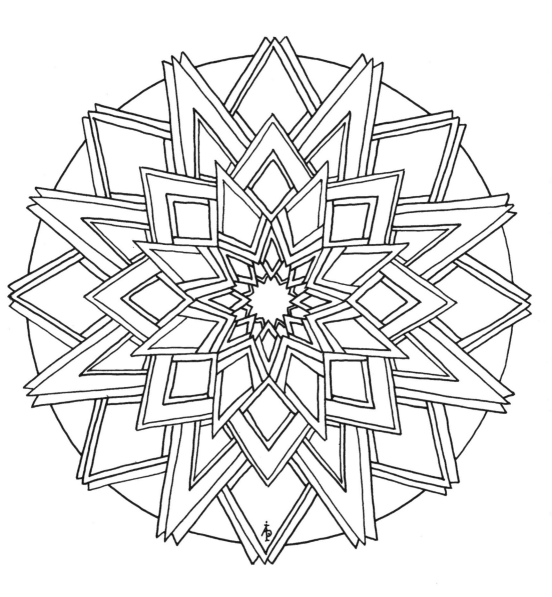

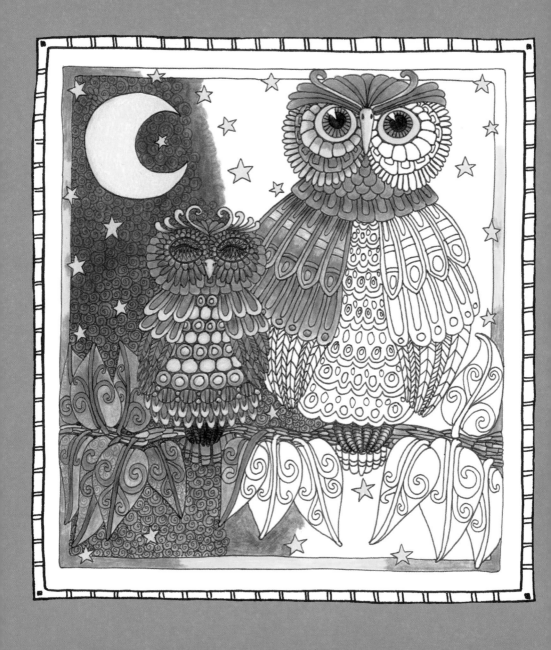

Chapter 5

FLORA & FAUNA

Objects found in nature are a common source of relaxation on many levels, including images of plants and animals. The geometric and repetitive patterns of fern fronds and butterfly wings, as well as the delicate shapes and beautiful colors of flowers, can be calming. Pictures of animals can also be soothing, especially when a cuteness factor is involved. The advantage of observing plants and animals is that it uses one's involuntary attention, which can actually counteract and ease the strain and energy put forth with those things that take one's voluntary attention, like focusing at work or accomplishing a task. Just the act of coloring these images of plants and animals may bring about a respite from the daily grind of your busy life. As you consider coloring the following pictures of various plants and animals, you may choose colors based on your experiences in the natural world, or try creating original color schemes. There is a blank panel at the end of this chapter to encourage you to draw and color an image of a plant or animal that you find calming.

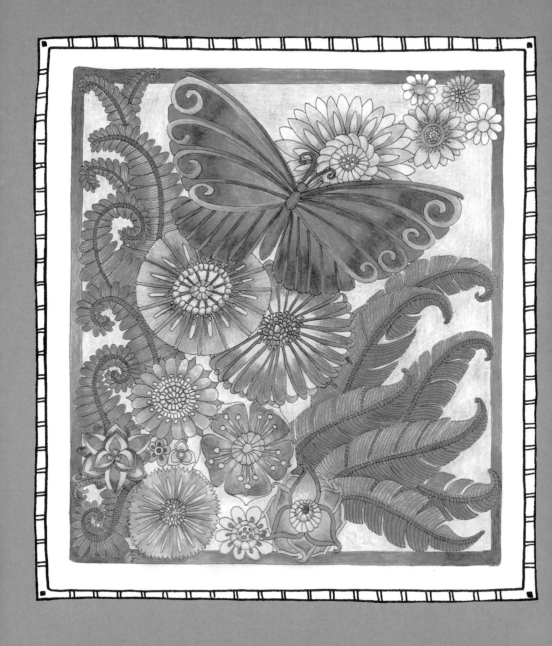

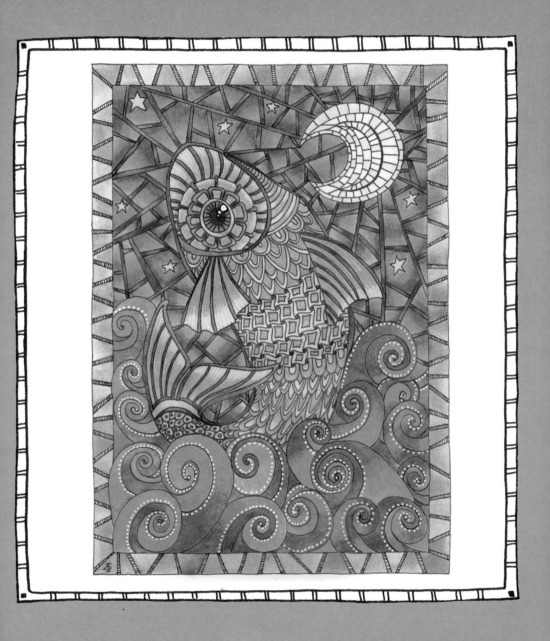

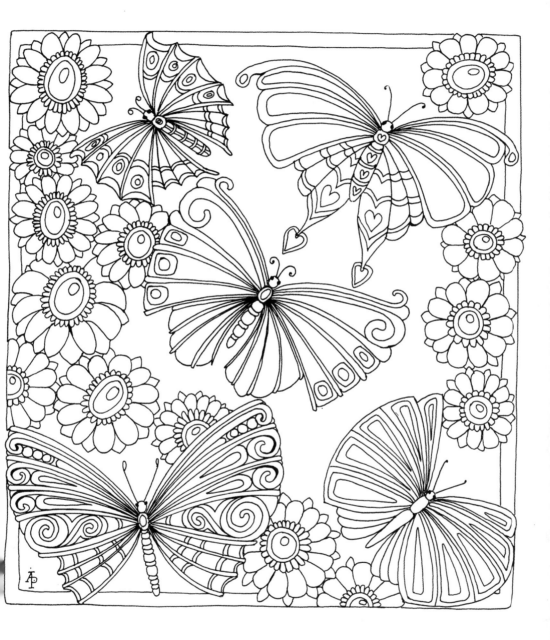

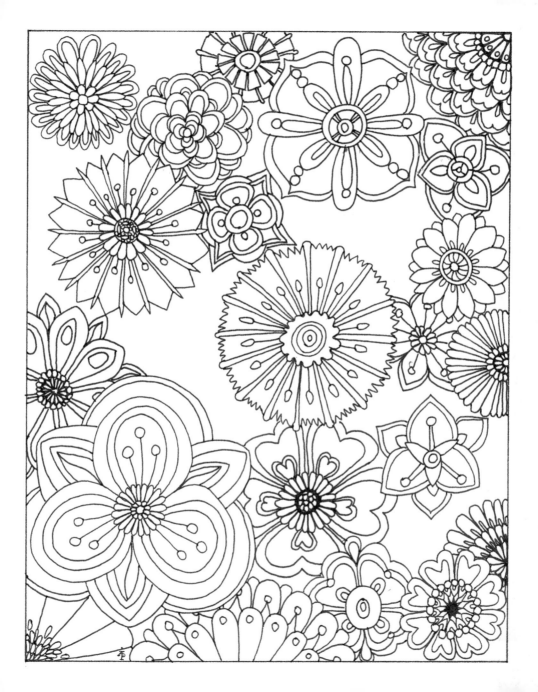

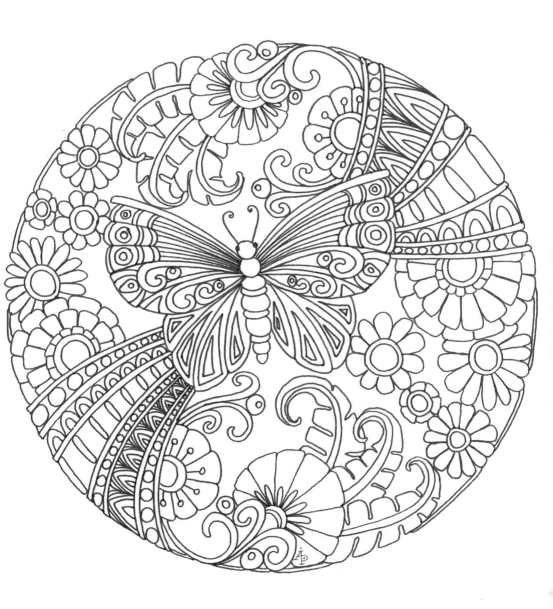

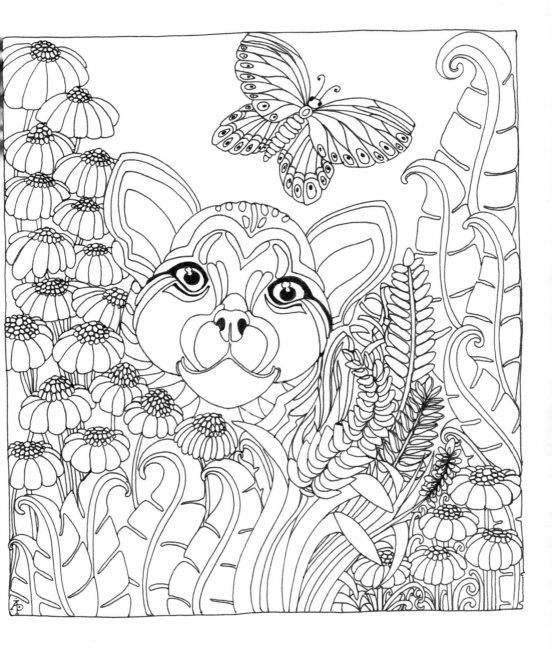

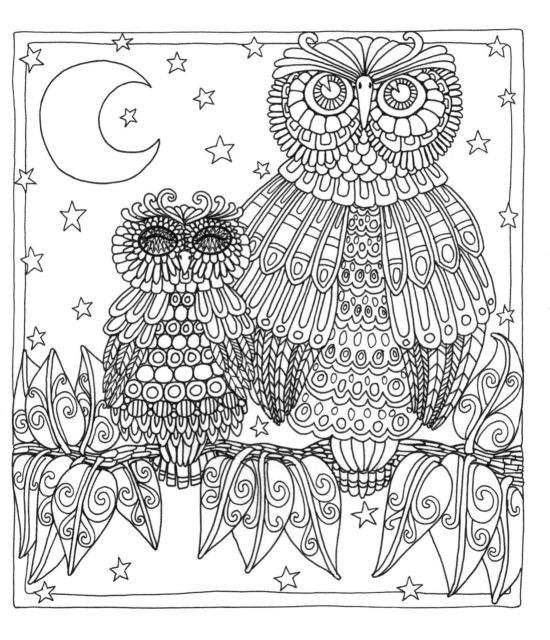

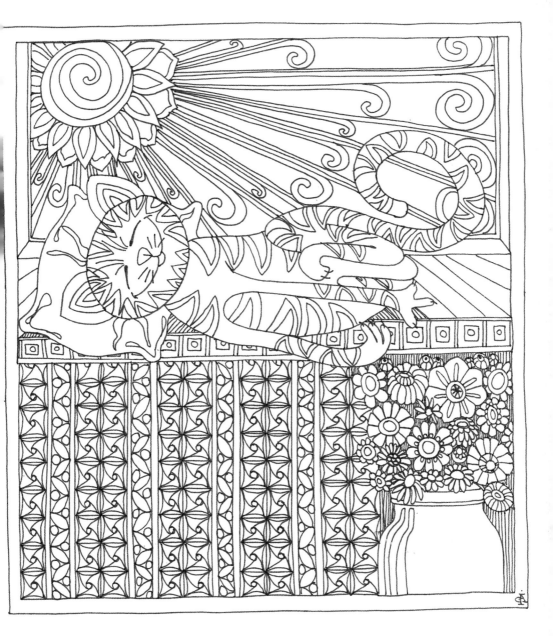

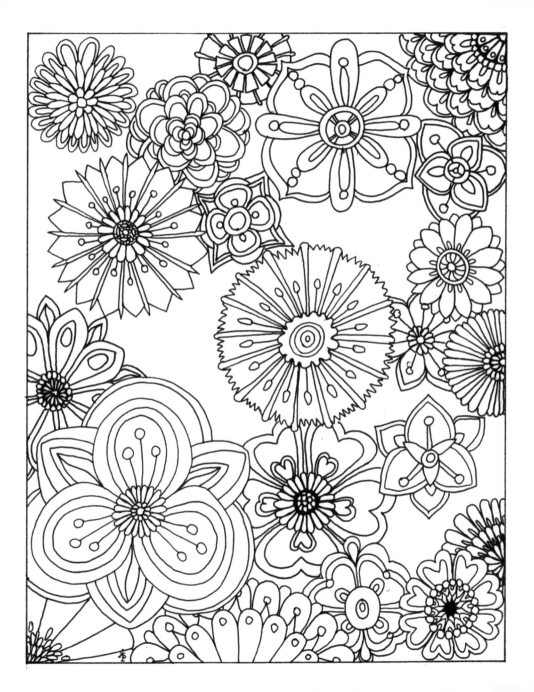

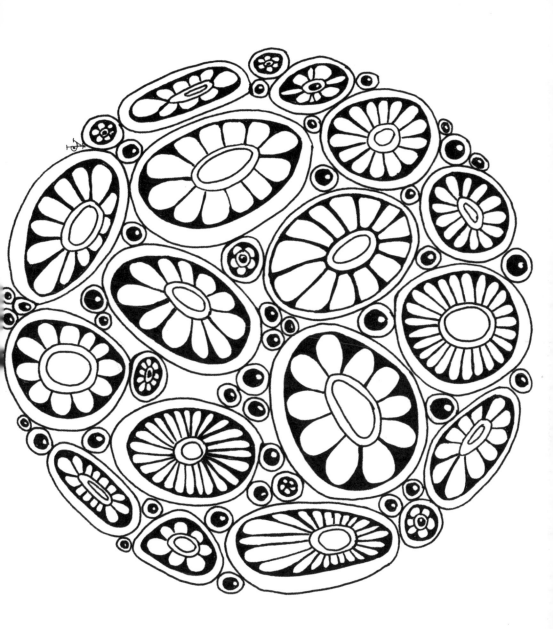

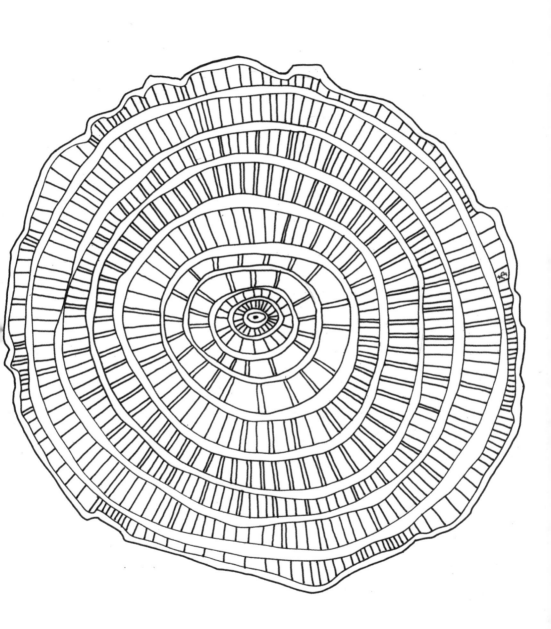

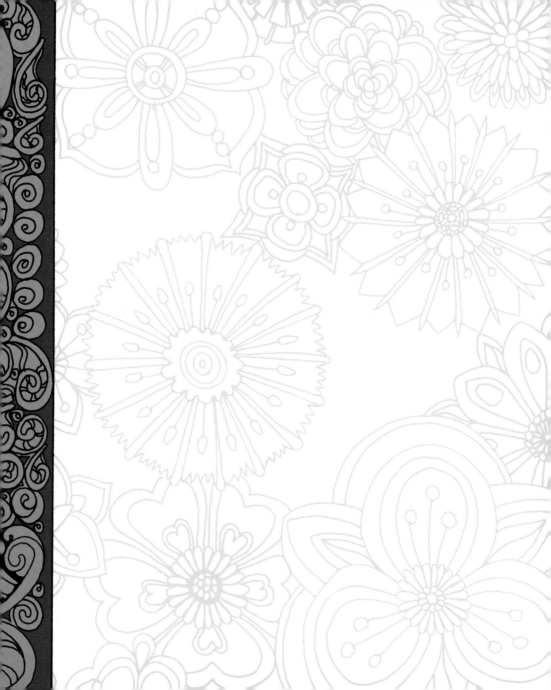

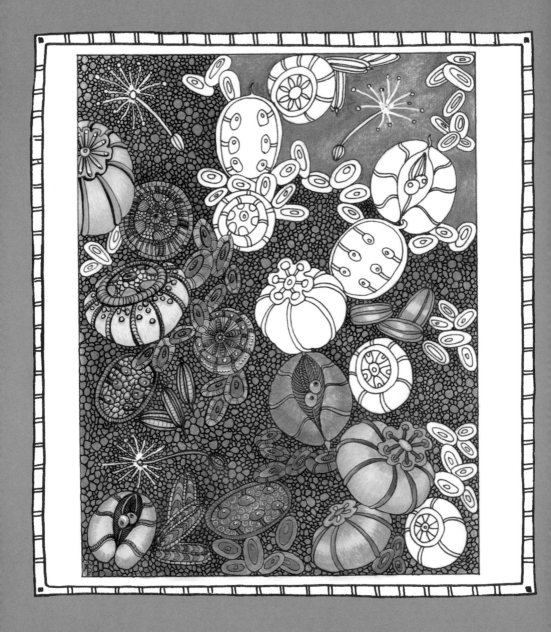

Chapter 6

NATURAL PATTERNS

The natural world gives us patterns that are pleasing and can bring about relaxation or soothe with their repetitiveness, simplicity, or beauty. Some of the shapes found in nature are symmetrical and bring a sense of order and balance; other patterns are more abstract, but their uniqueness may bring about curiosity or a sense of novelty. Research studies have shown that the observation of fractal patterns within nature can reduce stress up to 60 percent in people, based on the physiological reaction the body has when viewing these images. The relaxing effect also can be produced when viewing (or coloring) artwork including such natural designs. As you consider coloring the following pictures of various natural patterns that can be found in ammonites, snowflakes, trees, shells, and leaves, you may choose colors based on your experiences in the natural world, or try creating original color schemes. There is a blank panel at the end of this chapter to encourage you to draw and color a natural pattern that you find soothing.

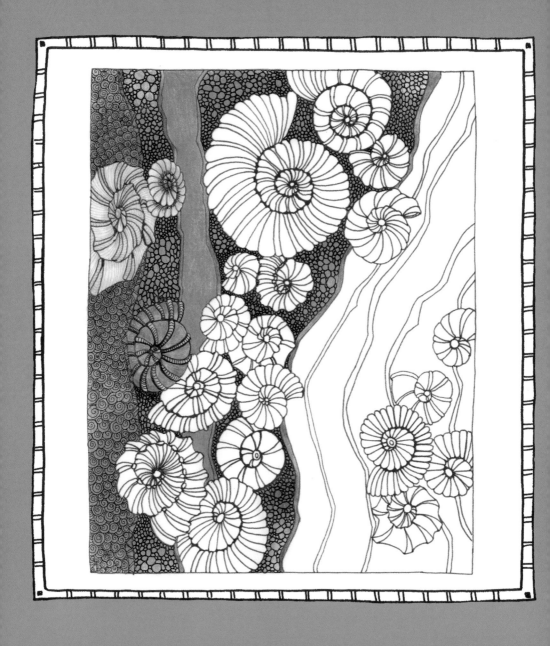

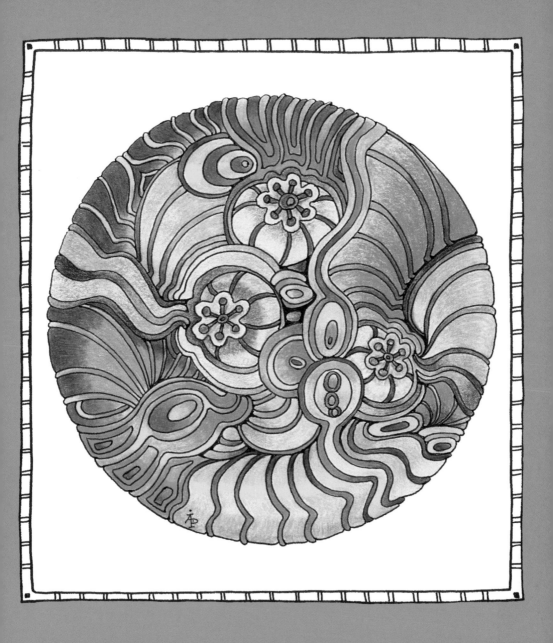

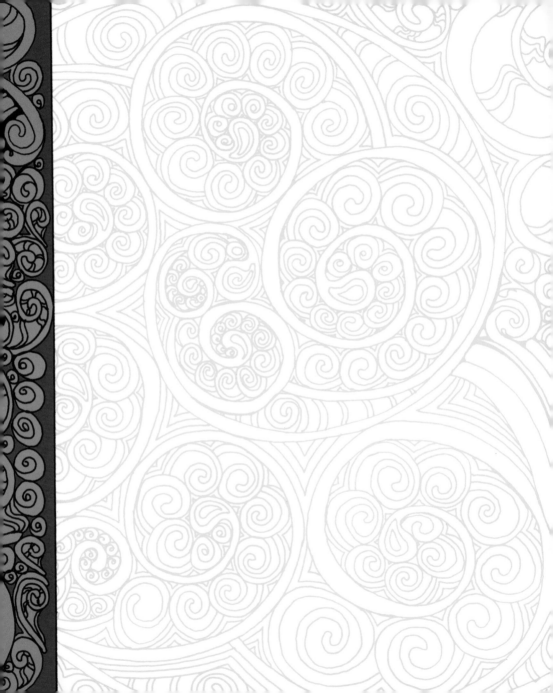

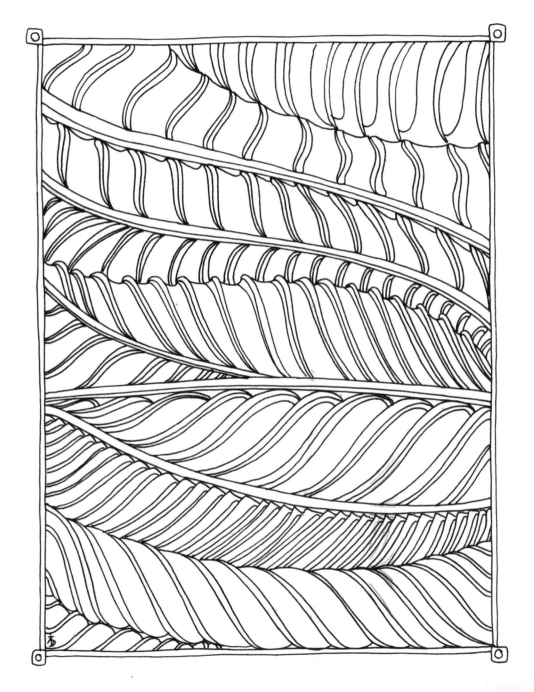

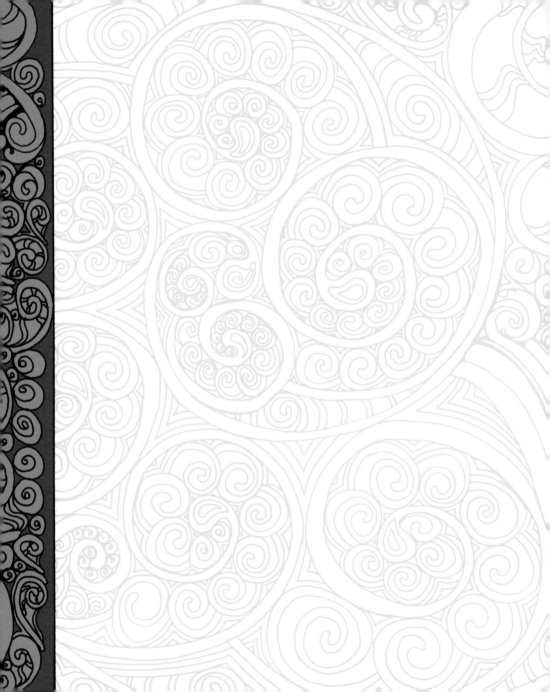

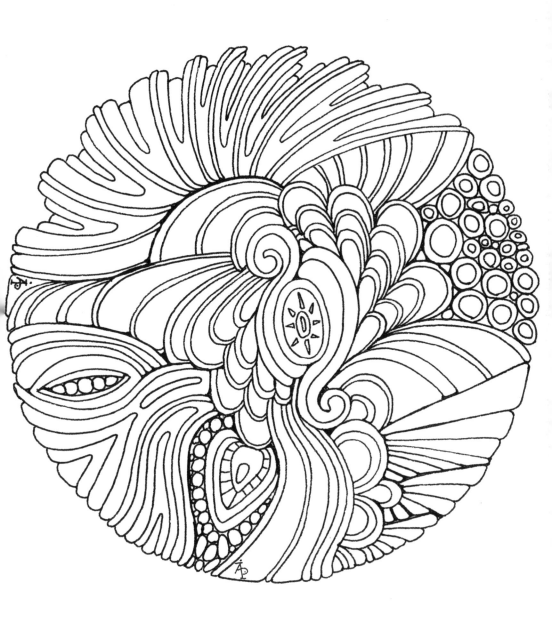

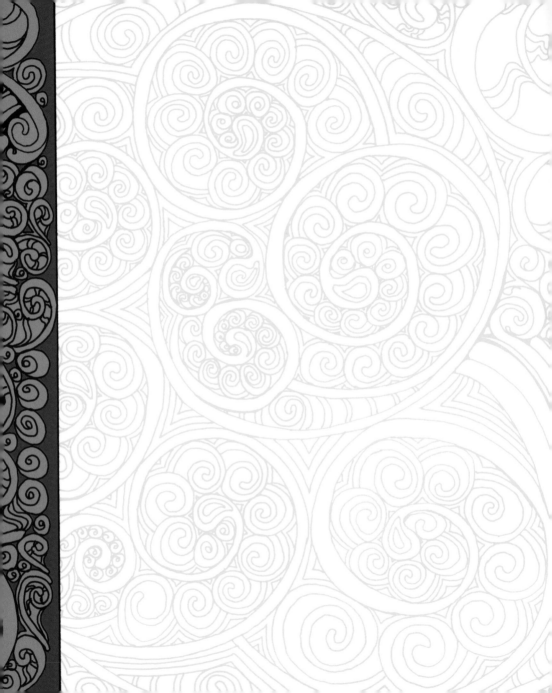

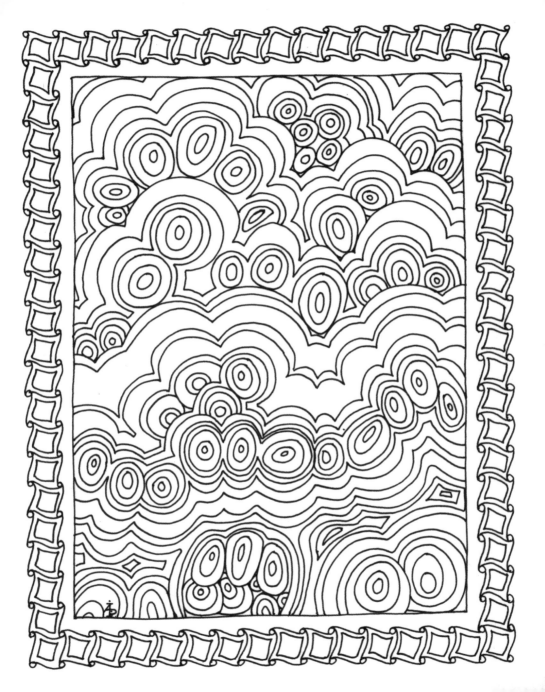

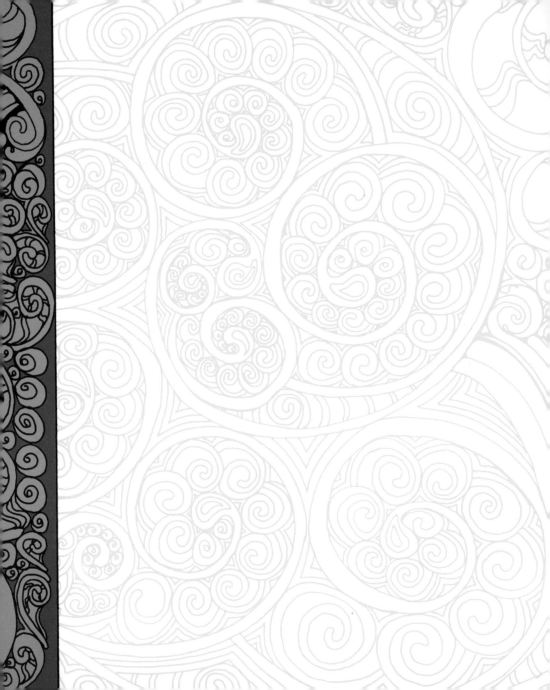

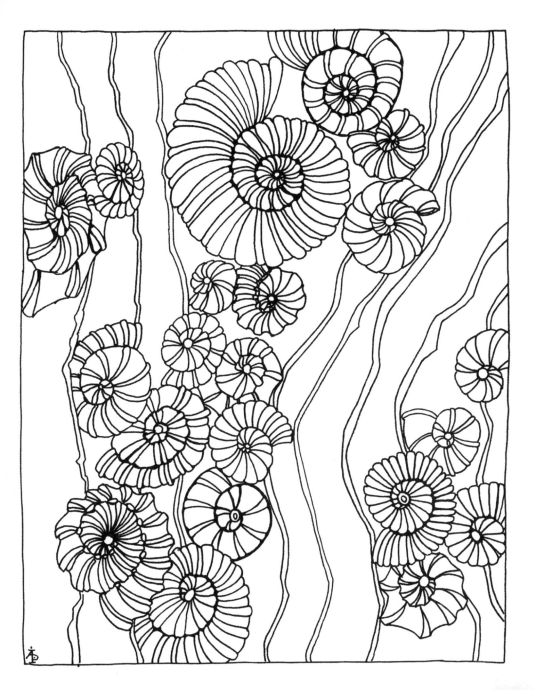

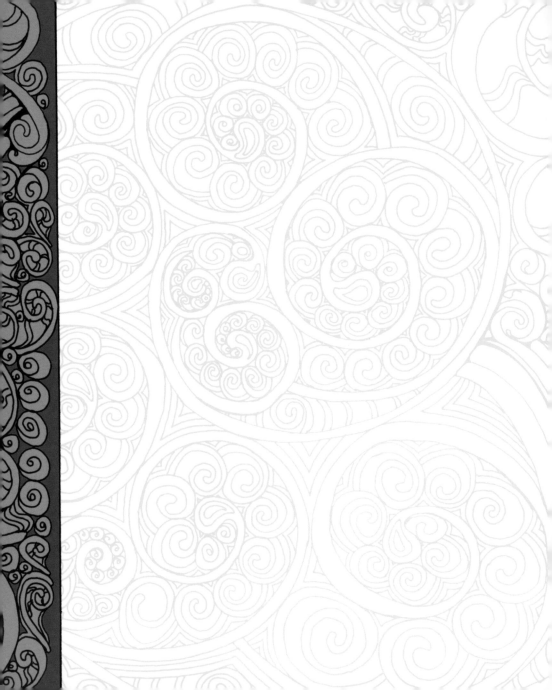

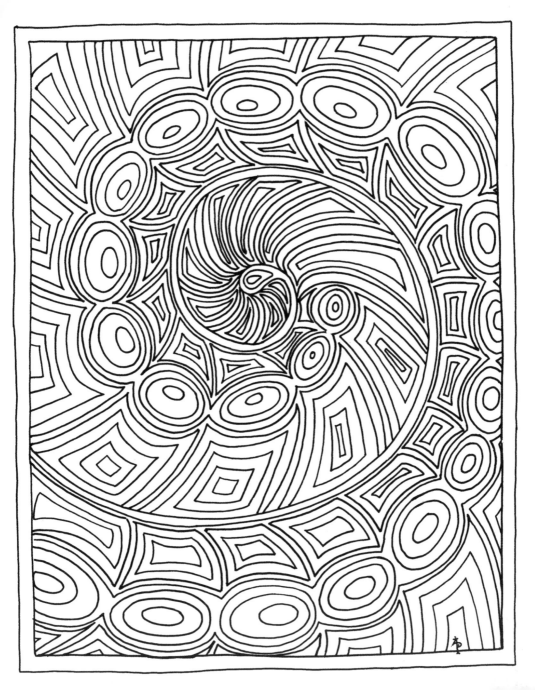

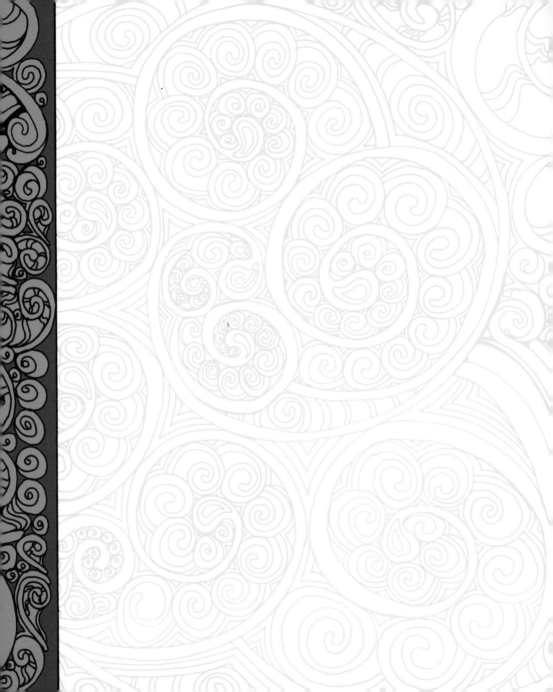

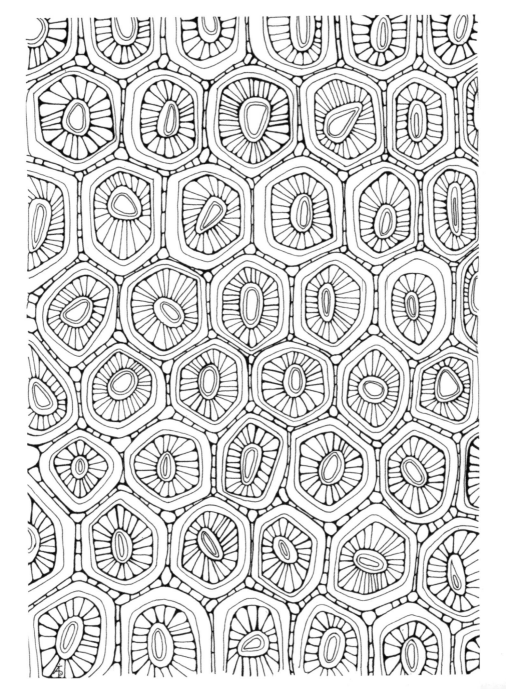

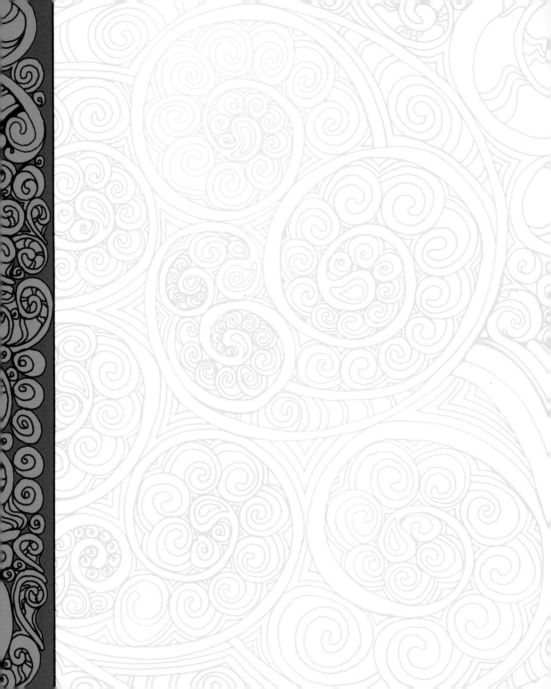

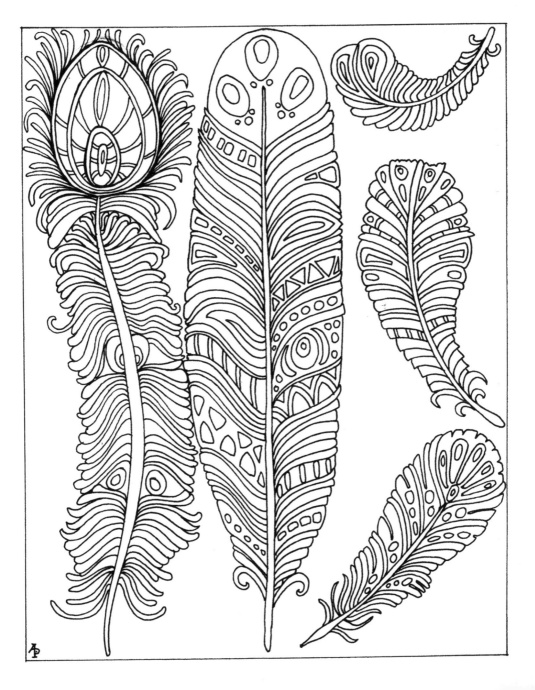

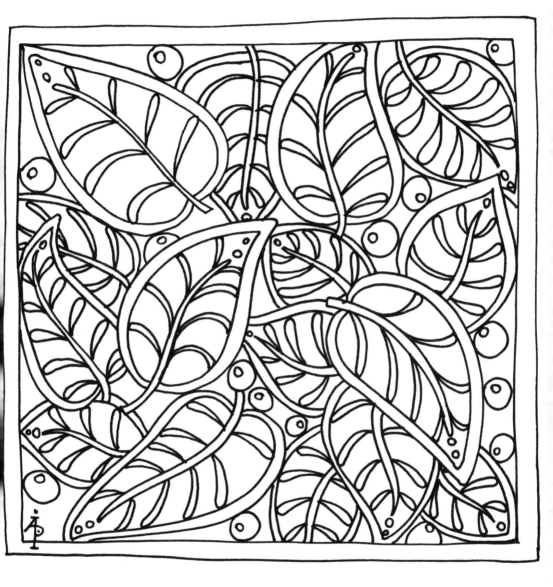

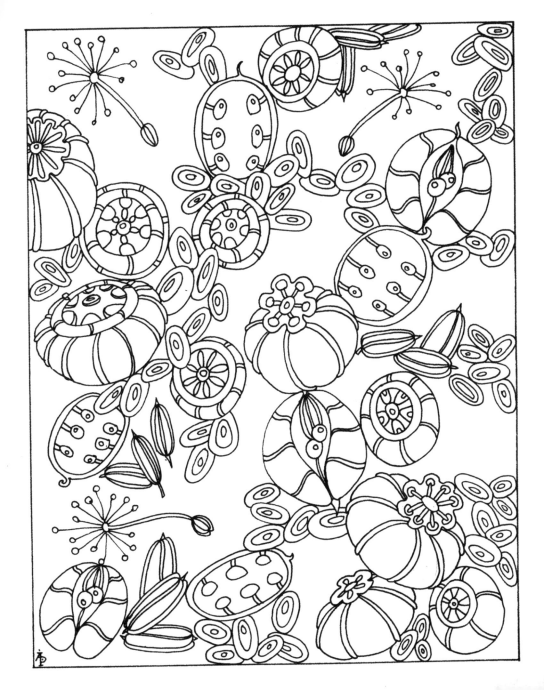

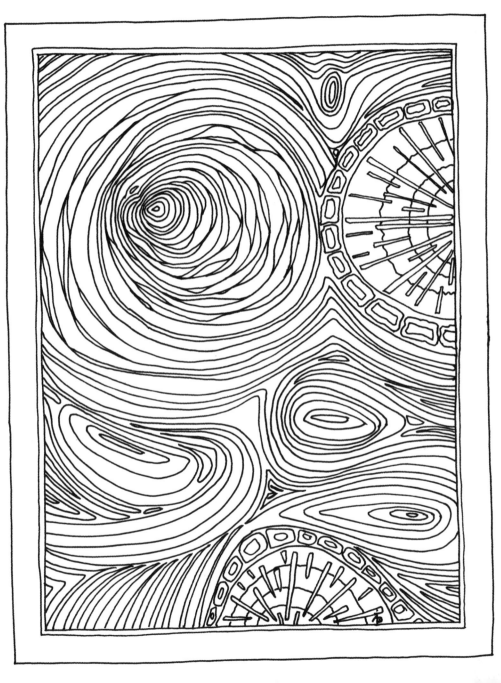